THE
CALLIGRAPHY
IDEAS
BOOK

D1407453

An Hachette UK Company
www.hachette.co.uk

First published in the United Kingdom in 2020 by
ILEX, an imprint of Octopus Publishing Group Ltd
Octopus Publishing Group
Carmelite House
50 Victoria Embankment
London, EC4Y 0DZ
www.octopusbooks.co.uk
www.octopusbooksusa.com

Design and layout copyright
© Octopus Publishing Group 2020
Text copyright © Lyndsey Gribble 2020

Front-cover image © Sabine Pick
Back-cover image © Jeremy Tow ETH

Distributed in the US by Hachette Book Group
1290 Avenue of the Americas
4th and 5th Floors New York, NY 10104

Distributed in Canada by Canadian Manda Group
664 Annette St., Toronto, Ontario Canada M6S 2C8

Publisher: Alison Starling
Editorial Director: Zena Alkayat
Commissioning Editor: Ellie Corbett
Managing Editor: Rachel Silverlight
Junior Editor: Stephanie Hetherington
Editorial Assistant: Ellen Sandford O'Neill
Art Director: Ben Gardiner
Designer: JC Lanaway
Picture Research: Jennifer Veall
Assistant Production Manager: Lucy Carter

ISBN 978-1-78157-746-2

A CIP catalogue record for this book is available
from the British Library.

Printed and bound in China

10 9 8 7 6 5 4 3 2

THE CALLIGRAPHY IDEAS BOOK

Lyndsey Gribble

ilex

Contents

Introduction

If, like me, you adore all forms of calligraphy and the craftsmanship it takes to create these beautiful letterforms, then I hope this book will provide you with a treasure trove of inspiration, techniques, mediums and styles to explore. There is no limit to the different styles of lettering a calligrapher can achieve during their lifetime, from mastering Copperplate, Spencerian and Modern, to Uncial, Roman and Blackletter. Once you start challenging yourself and stepping out of your comfort zone, the calligraphy world is your oyster.

Let this book be the start of your journey to discovering new forms of calligraphy from around the globe. Featured in its pages are dozens of traditional and not-so-traditional styles by contemporary trailblazers of the lettering world. This book is here to act as an inspiration and introduction to each concept. I urge you to delve further into all of the calligraphy ideas featured; not only will you expand your knowledge of this beautiful and diverse artform, but you will also discover new and unique directions for your own practice.

OPPOSITE:
My Sunshine,
Lyndsey Gribble

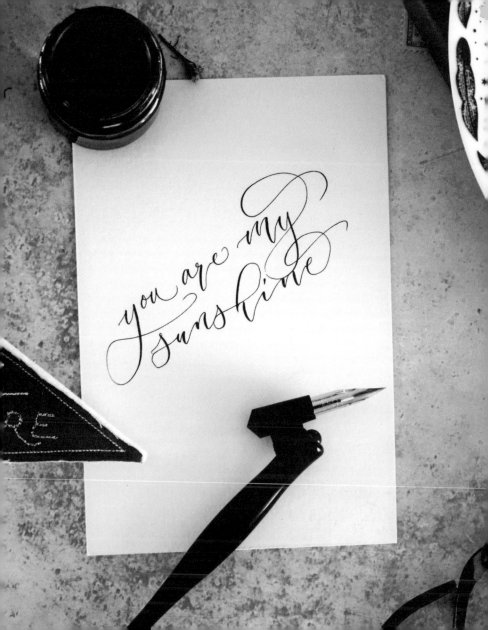

Practising Flourishing

TECHNIQUE #1

Zoé Brochard is a French calligrapher who uses familiar words such as names of months or well-known phrases to practise her calligraphy styles. This is a particularly good idea when you are new to flourishing because it allows you to quickly master writing the word in the first instance, and from there you can experiment with various styles of flourishing. Here, Brochard uses Copperplate script. She says, 'I really like flourishing this script and adding all these beautiful fine hairlines. This is a script that requires a lot of precision in the hand.'

To recreate similar effects, begin with small gentle flourishes until you are confident, and then work out where in the word you will position larger flourishes: at the end, the beginning or in the middle. Consider, too, where on each letterform you are going to place the flourishing; will it be on the ascender or the descender? A lighter touch is needed to create large ovals and fluid flourishes, and an oblique penholder will aid with this.

OPPOSITE TOP LEFT:
Elégance

OPPOSITE TOP RIGHT:
Flourished capital B in Copperplate script

OPPOSITE BOTTOM:
La vie est belle

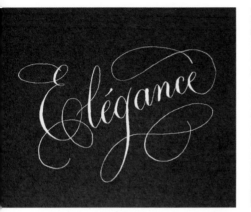

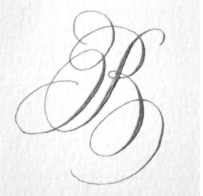

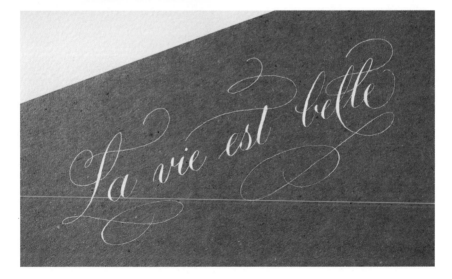

Letterpress

TECHNIQUE #2

—

Combining calligraphy with a print method, such as letterpress, is a great way to showcase your work. Stationery such as notecards, envelopes and invitations featuring calligraphy combined with letterpress is very popular. Joi Hunt of Bien Fait Calligraphy has combined her beautiful lettering style with a complimentary serif typeface, and then added an extra dimension and depth to her work with letterpress print. Hunt says, 'Having a wonderful relationship with your letterpress printer is essential; they will understand how to get the most out of your style with their letterpress printing techniques.'

Hunt uses a specific nib for this process – she states that the most flexible nib always results in thicker strokes when you apply pressure. This makes it easier for the letterpress-plate maker to create a plate that shows off the detail of the work, giving the calligraphy a luxurious, almost three-dimensional debossed feel to the touch.

ABOVE TOP:
Scripted notecards

ABOVE BOTTOM:
Cuneo monogram

OPPOSITE:
Cuneo invite 1

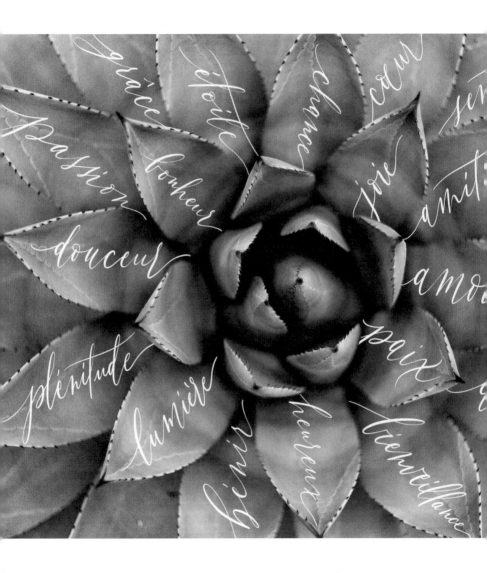

Combining Digital Calligraphy with Photography

APPLICATION #1
—

There are numerous ways to adapt your letterforms for online production if you want to use your calligraphy for digital creations such as websites, social media, or digital advertising. The calligraphy work of Callyane is a perfect example of one way to undertake this task: 'My creations allow me to mix old techniques (e.g. handmade calligraphy with a nib) with more modern renderings (e.g. integration of calligraphy in photographs).'

Callyane writes her letterforms out by hand, scans them into a computer and then uses a design program to tidy up the edges of her words. Using a program such as Photoshop, she arranges a composition over a photograph. In this example, it looks as though each leaf has been individually lettered upon.

Why not go through your photograph collection and see if any could be improved upon with the addition of calligraphy?

LEFT:
Love Cactus

Inspiration from Your Surroundings

INSPIRATION #1

—

A great way to develop your skills is to take inspiration from your surroundings as you write: what is on your bookshelf, on your walls, in your home, or in your natural surroundings? You could even let yourself be influenced by what you are listening to, as Claire Gould of By Moon & Tide has done here. 'This piece was inspired by one of my favourite musicians, Emily Barker, whose songs are hauntingly beautiful – and I wanted to reflect the delicate high notes of the song in the stretched out, exaggerated modern lettering on the page.'

Try taking a pen, ink and paper with you wherever you go and allow yourself to be inspired by your surroundings.

OPPOSITE AND BELOW:
The Artisan Calligrapher

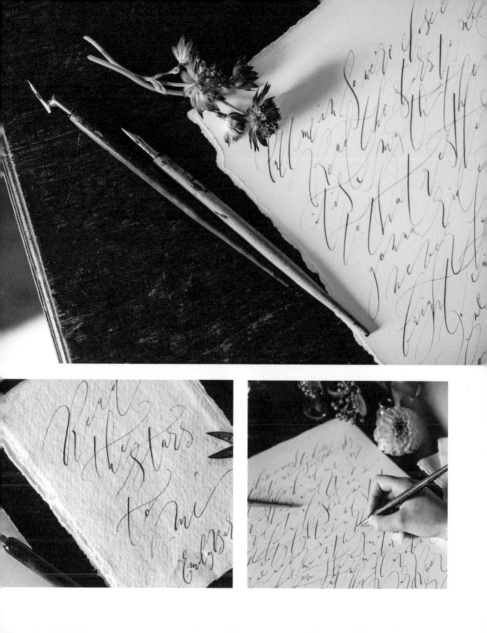

Vectorizing Ornate Letterforms

TECHNIQUE #3

—

The fine, delicate calligraphy letterforms created here by Chae Ho Lee require patience to create. His arrangement of flourishes results in elaborate pieces of art such as this letter 'I'.

'The work was inspired by the calligraphic letterforms of the famous penman Edward Cocker. I used the computer to draw vector points that require a precision in line and detail that is almost impossible to replicate by hand.'

The finished piece was created by importing the vector into Photoshop and editing the layer settings to show a final deep embossed finish.

To create something similar, search for your own historical calligraphic inspiration. Study pen placement and positioning – where hairline strokes need to become fragile flourishes and where sections intersect. Do a quick mock-up with a pencil, then draw directly into a computer program. Next, apply anchor points to your letter in positions where you can experiment with their placement and bezier curves. This task requires a lot of time, but it is well worth the effort.

OPPOSITE TOP:
The Letter I
embossed

OPPOSITE BOTTOM:
The Letter I
with vectors

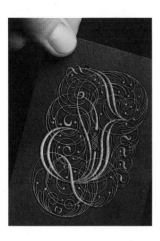

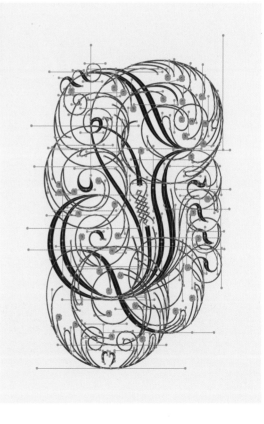

Out of his
heart
will flow
rivers of
living water

JOHN 7:38

Handmade Paper

MATERIAL #1

—

Calligrapher and papermaker Lauren Smith uses
traditional techniques to make paper. 'Making handmade
paper from plant fibres is a creative passion of mine and
I love the resulting natural textures that can be achieved.
However, it is a challenging surface for calligraphy as it
is often fibrous, roughly textured and highly absorbent.'

The most common issue arising when writing on handmade
paper is ink bleeding into the paper. Smith says, 'There are
a number of methods [for dealing with this,] but one of
the easiest is to use a fixative spray over the paper surface.
Choosing or mixing the right ink is also important. Thicker
inks will do better at not bleeding into the fibres but can
cling stubbornly to the nib. You can experiment with finding
the right thickness by mixing a few drops of gum arabic
into the ink and spot testing on a scrap piece of the same
handmade paper.'

Elevate your calligraphy practice by experimenting with
making your own handmade paper. Look online for paper
recipes to try.

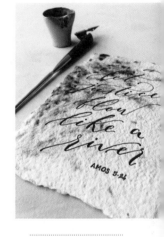

OPPOSITE:
Living Water

ABOVE:
Flow

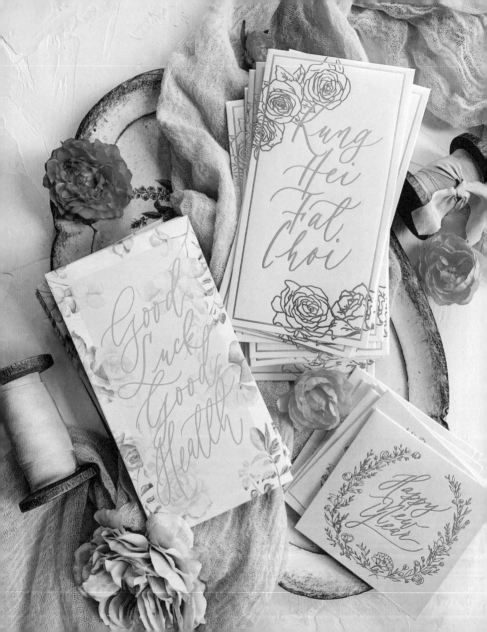

A Take on Chinese New Year Red Packets

INSPIRATION #2

—

Calligraphy is a diverse medium that can be used alongside any type of printed production such as these customized 'red packets' for Chinese New Year that Michelle Wong of November Letters created as a gift for friends and family.

She says, 'I first write the calligraphy writing with dip pen and black ink, then I digitize the words with a scanner and open them on Illustrator. I then finalize my design with Illustrator and print.'

The combination of this lettering style and design with such delicate illustrations makes these a beautiful gift idea for anyone. Try combining calligraphy with different print finishes such as foiling (or even letterpress) and interlacing your words through a floral illustration, as Wong has done.

OPPOSITE:
Red Packets Design

Agate

MATERIAL #2
—

Agate is a very tactile medium – its smooth surface allows for more precise calligraphy than writing on something textured that can catch the nib. It is also easy to source in many different colours.

Lauren Cooper from Oh Wonder Calligraphy, a wedding calligrapher based in the UK, likes to use agate in her work: 'I love to explore different materials to do calligraphy on and agate is one that is very popular with my wedding clients.'

When you are writing on a new surface, it is wise to research the best way to prepare it in order for the ink to adhere to the surface, as Cooper states: 'When working with agate, I prep the surfaces first with rubbing alcohol and then, using a very delicate touch, add the calligraphy. I use acrylic-based ink as it will not scratch off the shiny surface like water-based inks.' For an added layer of protection for your writing, you could also varnish the surface, or spray it with a fixative.

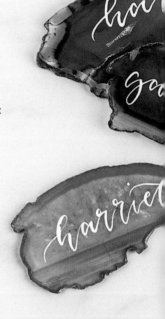

RIGHT:
Agate Slices

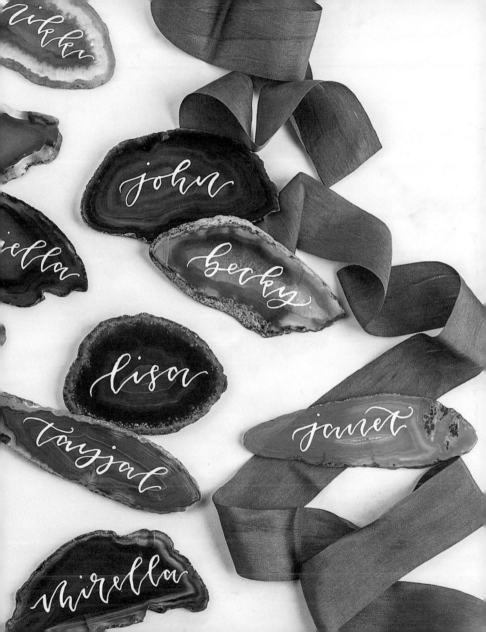

Perfectly Imperfect Letterforms

INSPIRATION #3

—

To refresh your practice, spend a little time out of your usual calligraphy comfort zone and have fun breaking the rules and creating perfectly imperfect letters. Use your imagination to create illustrative letterforms and compositions such as Sabine Pick has created here.

Pick says, 'I love starting with a warm up, writing the alphabet over and over again on all types of paper, especially old book pages. I don't often retouch the letters as I love the bits that are skew. I am always attracted to forms that are imperfect.'

Try writing some of your words fast, then slow; or larger than you normally would, and then smaller. Try writing to the beat of fast music, and then slow music; write as if you were angry and as if you were calm. You can even try writing with your weaker hand and see what imperfect perfection you can create.

OPPOSITE:
Lyrical Lettering

Our story

Across a crowded platform the girl with the coffee and the guy with the soundtrack to sing along with locked eyes — the rest is history

Whimsical Fine Art

STYLE #1

—

Fine-art calligraphy is an approach known for its detailed, elongated lettering. Each letter form consists of long gentle pen strokes with light pressure and exaggerated horizontal strokes. Laura Elizabeth Patrick's calligraphy is reminiscent of romantic Georgian novels, with ethereal pastels, hand-dyed silk ribbon and luxury handmade paper.

Patrick says, 'I like to write with vintage nibs, which allow me to take a fine touch and for the letters to take on a wispy, whimsical feel – perfect for a love note such as this. For this piece, I laid a watercolour wash over handmade paper. Once dry, I wrote very freely in pointed pen, using a vintage nib and black eternal ink.'

To develop such a technique, you need to break the boundaries of your usual writing method. You must learn to elongate your text and make it sit outside of the standard oval shape. Every stroke needs to be as delicate as possible. Do not put too much pressure on your downstroke, and extend your ascenders and descenders, noticing how they sit between neighbouring characters and also the space in between lines.

OPPOSITE:
Our Story

Figurative Art

INSPIRATION #4
—

A fascinating way to create calligraphic artworks is to combine Arabic calligraphy with illustration such as the work created here by Hicham Chajai. Chajai's original illustrative style unites with his fantastic mastery of the fluid lines of Arabic calligraphy to create these stunning works of calligraphic design, which play with the relationship between words and their meanings.

The unusual family tree on the page opposite is 'calligraphy based on the writing of names of a single family over three generations. The trunk is using the ancestors' names whereas the leaves [are] the youngest generation.' The traditional teapot shown above is made out of the words 'Moroccan Mint Tea'.

Let your imagination drive you as you create your own calligraphy illustration. This sort of intricate composition often takes a long time, but can be very effective once completed.

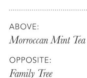

ABOVE:
Morroccan Mint Tea

OPPOSITE:
Family Tree

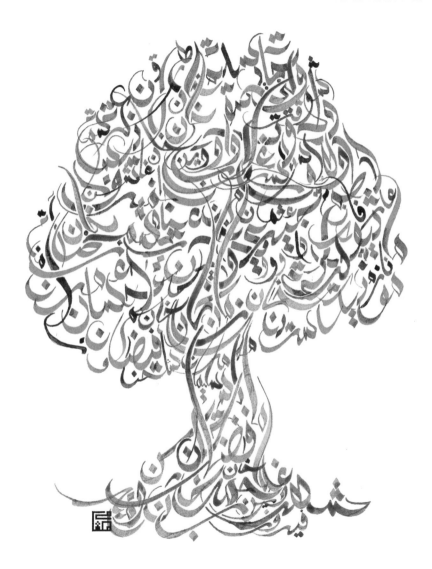

Ruling Pen Calligraphy

MEDIUM #1

—

Not all calligraphy needs to be created with a nib and ink. Ruling pens are another fascinating medium to work with, producing some really interesting pen strokes. Bakhyt Kadyrova says, 'These works are made by writing with a ruling pen over a wet watercolour. The interaction between ink and wet watercolours produces magnificent marks. The strokes are made with free whole-arm movements.'

Ruling pens are available from most calligraphy stockists, but there are also plenty of online videos showing you how to create your own by cutting up aluminium drinks cans.

Practise your usual lettering strokes, then change the pressure, angle of the ruling pen, or length of your lettering to create something that breaks away from the usual style of nib-and-ink calligraphy.

OPPOSITE:
The Origin of Gesture

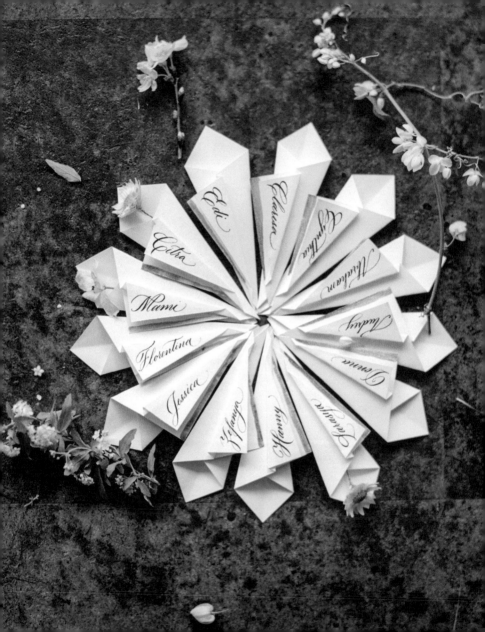

Folded Paper

INSPIRATION #5

—

As a calligrapher, it's important to remember that you are not limited to just a flat sheet of paper. There are many surfaces, paper stocks, print and folding finishes you can incorporate into your final design.

Here, international calligrapher Veronica Halim of Truffy Pi takes her lettering mastery to the next level with her *Origata Wheel and Origata Display*, which she says is 'inspired by the Origata, the art of Japanese gift-wrapping folding.' She used black ink with a gold accent to create these place settings. Halim has taken something as simply satisfying as paper folding and created a piece of work so bespoke that it turns this place setting into a beautiful work of art.

Why not create your own origami and calligraphy combination by folding some luxury handmade paper into your chosen design? The finished pieces would make the perfect keepsakes for guests at a wedding or dinner party.

OPPOSITE:
*Origata Wheel and
Origata Display*

Greetings Cards

APPLICATION #2

—

Christmas is the best time of year to whip out the metallic watercolour palette and make your lettering really come to life. You could write a festive quote, add emphasis to a certain word with metallic flourishing or, as Lindsey Bugbee of The Postman's Knock has done here, you can transform flourishing into an illustrated iridescent Christmas card.

Bugbee says, 'I love to write with watercolours because they are so portable and mess-free! The basic idea is you moisten the watercolours, brush them onto the back of your nib, and write.'

Get inspired by the festive season and really go to town with a metallic watercolour palette. The colours are made of mica, which reflect the light beautifully and illuminates your work. Adjust the consistency according to your preference – a thicker ink will sit nicely on coloured card.

RIGHT:
Woodland Watercolor
Wreath place card

BELOW:
Metallic Gold Watercolor
Flourished Tree

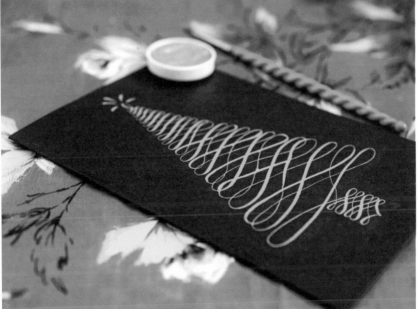

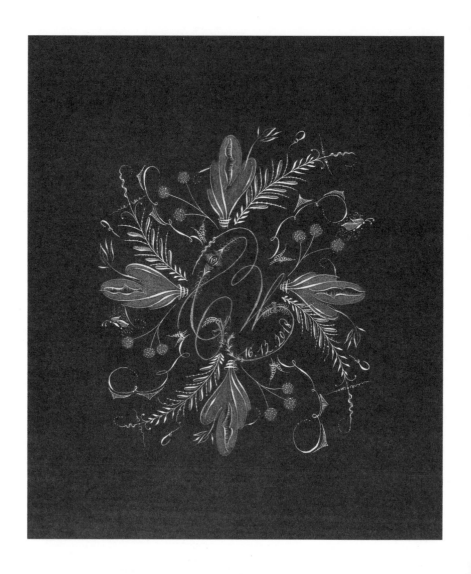

Illustrative Flourishing

INSPIRATION #6

—

Imaginative hand-crafted projects make the ideal gift. There is a huge scope of beautiful calligraphy work you can produce with a nib and ink – and not just letterforms. Take this flourished Copperplate illustration created by Anika De Souza of 55 Degrees Calligraphy for example. 'This mandala was created for the arrival of my friends' daughter. Her initials and date of birth are found at the centre of the design. The initials are inspired by the Real Pen Work (1884) found at the IAMPETH Collection.'

This technique can be challenging. Begin with mastering pen control, consider your negative space and the arrangement of your pen strokes. De Souza says, 'I always start with a circle, which I divide into segments using a white pencil. I then create elements along those lines, rotating and repeating, and looking for empty spaces to fill with flowers, twirls, ovals, etc.'

To aid your calligraphy progression consider joining IAMPETH (The International Association of Master Penmen Engrossers, and Teachers of Handwriting) to study under a Master Penman to refine your calligraphy lettering skills.

..

OPPOSITE:
Flourished Mandala

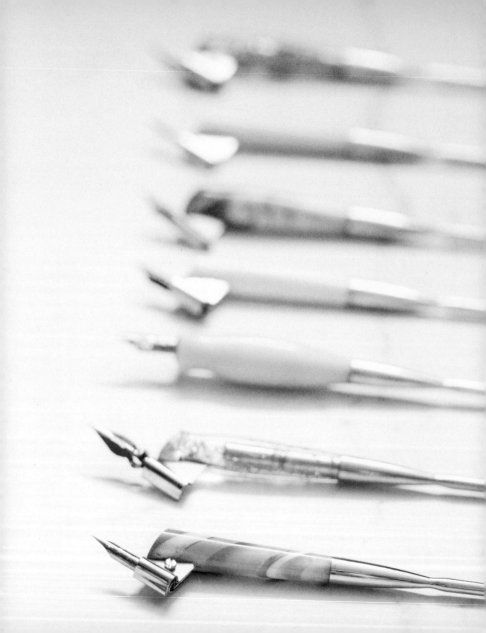

The Perfect Penholder

MEDIUM #2

—

Calligraphy can be addictive, and when the bug hits, you'll be hard-pressed to resist buying all the accessories and tools available. Sourcing the right inks, nibs and penholders is about finding the equipment that will become a part of your own character, and that of your work.

Each pen Tom Gyr creates is personalized to the character of its owner. Every pen is handmade by Tom using a blend of traditional craft techniques with state-of-the-art manufacture. This enables him to create a precise and balanced writing experience with the soul of a product only achieved by a craftsperson.

When you start your calligraphy journey the chances are you'll first use a straight penholder, and as you become more confident you'll venture into using oblique holders. Enjoy buying and experimenting with different penholders from thick carrot shapes to ergonomic curved ones.

OPPOSITE:
A batch of custom calligraphy pens

ABOVE:
Dorset Wildflower oblique calligraphy holders

Laser Cutting

INSPIRATION #7

—

A laser-cutting machine allows you to turn your own lettering into something unique and tangible. These pieces make perfect products to sell or give as gifts – consider possibilities such as wall hangings and signage. Marie Tsuneishi uses her calligraphy lettering to create her own laser-cut cake toppers.

Tsuneishi says that even when working on a digital design, she always starts with a first draft in pen and ink on paper. Starting your initial design by hand is imperative to work out the positioning of your lettering and how it will all connect together so it does not fall apart during the cutting process.

Ideally, you need access to a computer with a design program such as Illustrator, and a means to scan your artwork into said program. Alternatively, you can use an iPad or tablet with a good lettering app: take a photo of your mock up, use your Apple Pencil or stylus to trace over it on a separate layer, and then vectorize the result (see pages 54 and 98). Always check to see what file formats are suitable for the laser-cutting machine you are using, be it your own or a supplier's.

OPPOSITE:
Original cake topper
Best Day Ever

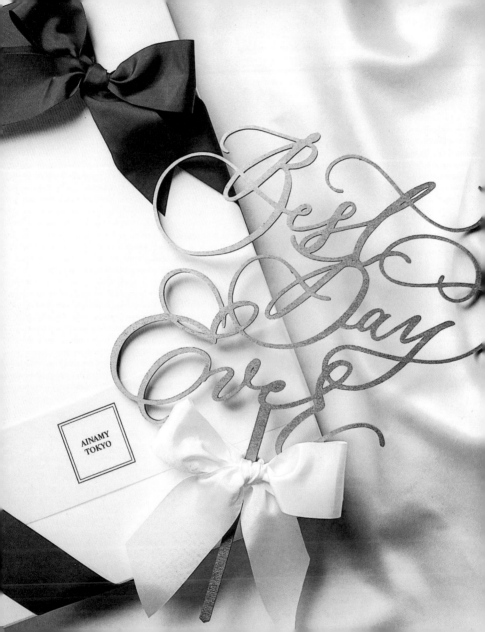

AINAMY
TOKYO

Let yourself be Broken
and you will be Whole

Let yourself be Crooked
and you will be Straight

Let yourself be Empty
and you will be Full

Let yourself Grow Old
and you will be Renewed

Lao Tzu

Spencerian Penmanship

STYLE #2

—

Any aspiring calligrapher interested in furthering their learning should pursue a well-rounded knowledge of all the main calligraphy techniques, and one style that is well known for its beautiful fluidity is Spencerian calligraphy. Spencerian was the prevelant style in the USA in the late 19th century, created by Platt R. Spencer Snr and used for business letters and similar documents.

Bakhyt Kadyrova's work demonstrates her mastery of Spencerian script. To create this lettering approach, Kadyrova says, 'The main features of this technique are free whole-arm movement, even rhythm created by the even movement of the forearm for compound curves, specific distribution of shades for capitals, and generous flourishing.'

Kadyrova also researches penmen to study their method of writing, something that can be done by searching online, studying texts or visiting the IAMPETH website.

OPPOSITE:
Lao Tse Quote

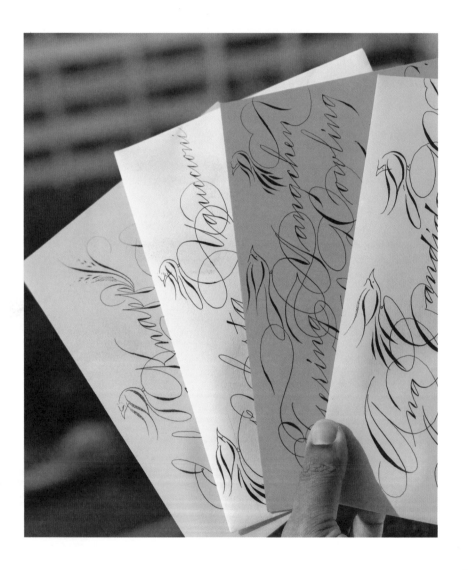

Envelopes

APPLICATION #3
—

Wherever they may live around the globe, everyone loves to receive beautifully decorated envelopes. Imagine the joy of receiving the letters of Amarjeet Sonkar of Being Uxer shown here, which showcase his ornate Spencerian calligraphy.

Addressing envelopes can be a way for you to improve and develop your style. In the examples shown, Sonkar has used intricate flourishing to create breathtaking artworks. Consider how you want to lay your address out – will it be left aligned or centred? What size envelope will work for you and how much room do you need for your writing style? If you plan to send your envelope by post, be sure to use inks and paper stock that can withstand long-distance travel and rainy weather conditions – and remember to leave enough room for the stamp.

There are tools available to help a novice with lettering alignment on an envelope such as the Lettermate, which is available to buy online.

OPPOSITE:
Envelope Calligraphy

La più
grande
libertà
nasce
dal più
grande
rigore

VALÉRY

Italic

STYLE #3
—

The beauty of Italic calligraphy is in its delicate extended letterforms. Note the characteristic slant line created on this Paul Valéry quote by calligrapher Chiara Riva, using a Brause nib on high-quality paper stock. Riva says, 'The letters are written with some variation of pressure within the strokes, extending the terminals of the letters.'

The letterforms are all proportional to each other, which makes them easier to read than many other types of hand lettering – even when incorporating flourishing – hence its widespread popularity as a script today.

In contrast to styles with a delicate signature flick at the end of each letter stroke, Italic has a gentle pen angle. To achieve this, try using a flat or square-edged nib, and practise keeping letters proportional.

OPPOSITE:
La Più Grande Libertà

Wiste

Xeranthemu

Yarrow

Graphite

MEDIUM #3
—

Calligraphy can be frustrating, especially at the start of your penmanship journey when you are learning the intricacies of the artform. This feeling is not reserved solely for beginners, as Jane Izumi Matsumoto describes, 'One day, I became quite frustrated with my ink blooping, the nib catching on paper, and having to restart projects over and over again. So I switched to starting all projects with a pencil.'

Remember calligraphy is about being mindful, so take a step back, breathe and relax, learn to strip away any frustrations and take your time. With a pencil, you can focus more on the creation of the letterforms than on the control of the nib and ink, thereby taking away a level of stress that sometimes gets in the way of creating your perfect project. Izumi Matsumoto also notes that pencil can be extremely useful for adding shading and dimension to your letterforms. Try an HB or even the popular Palomino Blackwing pencil to begin with.

OPPOSITE:
Graphite Flourishes

Letterpress Business Cards

APPLICATION #4
—

Letterpress business cards such as these created by Kestrel Montes of Inkmethis Calligraphy & Engraving add a feeling of luxury to your brand. By letterpress printing her lettering onto a very high-quality paper stock, Montes is letting her potential clients know what to expect from her, her business and her brand when they work with her. She says, 'Pointed-pen calligraphy is beautiful; when used in letterpress, it is stunning. Your calligraphy becomes a three-dimensional piece of art.'

There are various ways to digitize your calligraphy in order to provide your letterpress printer with a vectorized digital image file. Montes says, 'Programs such as Vector Magic offer inexpensive monthly plans for easily transforming images to vectors.'

Once you have created your artwork, you will need to liaise with your printer about the dimensions of the plate and the type of paper stock you will be using. A cotton-based paper is ideal as the lettering on the plate will leave a lovely deep impression when printed.

OPPOSITE:
Press plate used in making Kestrel's business card

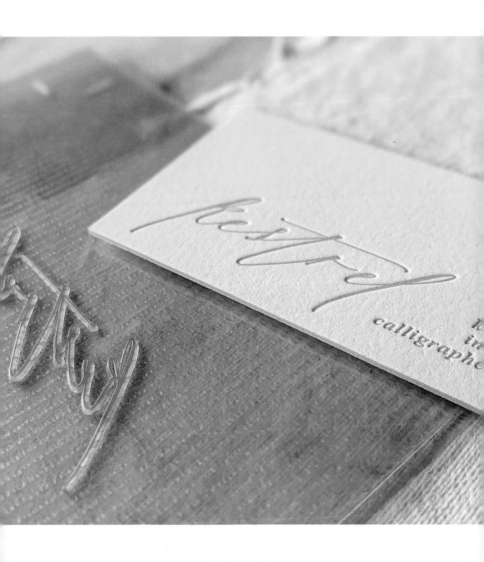

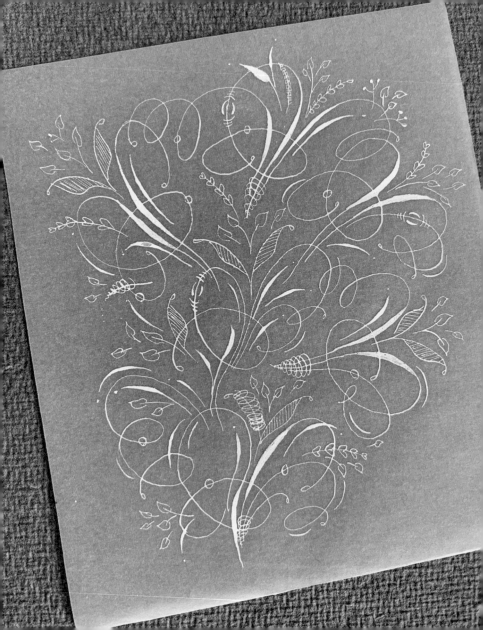

Having Fun with Flourishing

INSPIRATION #8
—

Once you have mastered basic flourishing, you can begin to branch out and investigate the techniques of fellow penmen from around the world to help broaden your knowledge.

Jessy Lim of Jescreates, a Malaysian artist living in Singapore, takes the time required to develop her unique flourished style. She says, 'The flourishing mostly came from the basics of cartouches flourishes. It is a series of ovals and smooth curves, adding leafy foliage, wheat flourishes and other type of flourishing elements to it.'

You can start to experiment with flourishing by tracing out ghost ovals with a light graphite pencil, allowing you a form of guideline that can be erased when your ink has dried. Try an oblique penholder just as Lim uses, combined with a Leonardt Principal EF Nib.

OPPOSITE:
Bouquet of
Cartouches Flourishing

Digital Calligraphy

MEDIUM #4

—

Two of the best recent technological developments for calligraphy are the iPad Pro and the Apple Pencil. Use them with lettering apps such as Procreate, and you can download or make your own fantastically realistic calligraphy brushes. This gives you the opportunity to letter without the immediate fear of not being able to correct a mistake made in ink.

This work by Ruthie Cawley of Cawligraphy is a fine example of using this medium. She says, 'I will often have an idea of how I want the lettering to look as a finished piece, but it might take a few attempts to letter it and get it looking how I want it to. Once I'm happy with it, I'll letter it on my iPad with my Apple Pencil. I'll then transfer it across to Illustrator and vector it. Then the tricky part – which colours to choose!'

It can be worthwhile to invest in expensive equipment if you know you will utilize it for a lot of your work. The programs are extremely versatile and give you the opportunity to get completely carried away with creating as many layers of lettering as possible.

OPPOSITE:
Flowers

flowers
need time
to bloom
+ so do you

Japanese Calligraphy

STYLE #4
—

The arrangement of letterforms in this calligraphy by Keiko Shimoda is utterly mesmerizing. She has studied her art from an early age and works in a variety of calligraphic styles, one of the main ones being Japanese calligraphy. She uses Japanese Sumi ink and writes on Japanese paper with a brush. Each individual letter is meticulously placed in proportion to the next letterform, the arrangement of which results in this delicate piece of artwork.

Shimoda is inspired by Japanese and Chinese poems relating to the snow or wintery scenery. She has combined the traditional Hiragana Japanese alphabetic forms along with the classic cursive Kana calligraphy, and used a fine, pointed pen brush and cursive writing to create these pieces of work. Kana and Hiragana are very interesting Japanese ways of writing and illustrating the alphabet and lettering. It's worth researching online for further information.

RIGHT:
はつゆき *(First Snow)*

みやゝはめてゝようはゝゆゝを

よのやゝにふりやゝわらむ

銀河沙汰三子里梅嶺花桃一万株

雪以鶺毛飛郡乳人枝語鶯立俳個

翅以得居栖浦鶺心魔変興梼子人

みゝしゝ山のらゆゝつまゝし

小さゝをむくなりまうなわ　是則

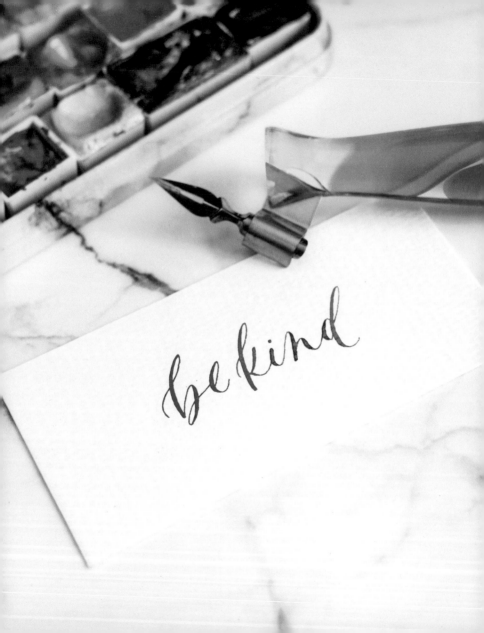

Gradients with Watercolour

MEDIUM #5

—

Watercolour is exceptionally versatile, and it's fun to mix up your own colours from a pan or a tube to use as an inexpensive medium for calligraphy. If you are using it from a pan, you will need to add water a few drops at a time to create the correct consistency for the type of project you are working on.

Mai Lagdameo demonstrates here how well Aloha ink and handmade watercolours can be used as a calligraphy ink. Lagdameo says, 'To create this blending effect, I start with one colour, and gradually add the next colour to create this almost gradient-like look. I love watercolours and the endless possibilities of colour combinations you can create!'

Start by experimenting with watercolour in your ink, and then branch out like Lagdameo and see if you can create a gradient. The list of inks you can use for this technique is endless, from sumi, Liquitex and Finetec to iron gall ink.

LEFT:
Be Kind

Wedding Stationery

APPLICATION #5

—

Romantic calligraphy and luxury handmade paper are the perfect ingredients for exquisite wedding stationery. Michaela McBride's combination of a rich dark paper stock and hot gold-foil letter printing creates stationery that has an expensive and stylish air. McBride says, 'Each piece of calligraphy illustration used within our designs begins with pen to paper – from there the calligraphy drawing is scanned, cleaned and digitized for use on the invitation. Our designs and style have really developed from our own personal love of paper, finely created goods and weddings!'

To create your own wedding stationery suite, finalize your design then consider how to style it. You could add some hand-dyed silk ribbon or a personalized monogram wax seal stamp to tie all the elements together. Consider making a hand-folded envelope with matching paper and gold ink.

OPPOSITE:
Floral Sketch
foil printed on
handmade paper

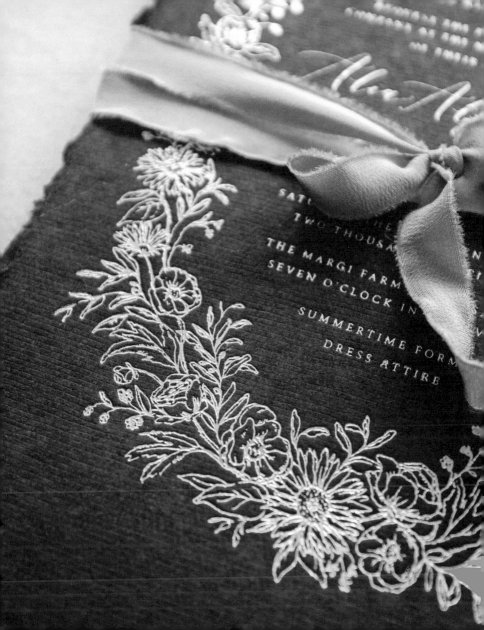

i do no

some pl

the s

in the

it

Embracing Unpredictability

INSPIRATION #9
—

The beauty of Modern Calligraphy is you don't have to be constrained to any particular style, angle or stroke length. You are free to experiment and to see where your nib and ink take you. Rachel Jacobson makes great use of this spontaneity and unpredictability in her approach to lettering. Jacobson says, 'I was trained in Italic and more formal calligraphy hands, and that's influenced my approach to contemporary calligraphy styles. I enjoy writing with quick, gestural strokes, experimenting with scale and embracing the natural rhythm that writing by hand lends itself to. For this reason, I prefer inks that flow well, revealing nuanced lines and the natural variation of the ink against the paper's texture.'

Why not take a quote, word or some of your favourite song lyrics to experiment with? Write them out in your usual lettering style and then repeat, trying to change your lettering each time. Play around with elongating your strokes, adding more bounce to your loops, and increasing or decreasing your pen pressure.

OPPOSITE:
Untitled

Calligraphy with Watercolour Illustration

MEDIUM #6

—

A few wonderful artforms work hand in hand with calligraphy; watercolour painting is one of the most popular. Harriet de Winton is a trailblazer in the watercolour world and her work combining calligraphy with her watercolour artistry encompasses everything from bespoke gin table plans to ornate and detailed wedding stationery and venue illustration.

In the artwork featured here, de Winton has combined calligraphy ink, fineline pens and watercolour to produce beautiful cocktail recipe cards. She says, 'I love how well watercolour can depict liquid, and the sploshy nature of the painting adds energy and movement to the illustrations. I first illustrate the drink with waterproof fineline pen and then paint a layer of watercolour on top. Once that is complete, I add the calligraphy last.'

Why not make your own watercolour and calligraphy recipe cards next time you are entertaining friends?

OPPOSITE:
Cocktail recipe cards

The art of a good

Hugo

dful of mint
derflower cor
Prosecco
Ice

th Ice, add a handful
derflower cordial.

The art of a good

Aperol Spritz

a handful of ice cubes
Aperol
Prosecco
a splash of soda water
1 slice of orange

Add lots of ice to a large white wine glass. Pour over the Aperol, followed by the Prosecco. Stir once and finish the drink with a splash of soda water and a slice of orange.

The art of a good

Negroni

Gin
Campari
Vermo

Pour equal parts

I'm so grateful I met
fifteen years ago at
_ Marie's wedding.
_hat you've been my
_m and rock from the
_e started dating. And
_en your number one
_supporter. I love our
_ren & the life we have
_ I've loved making
_ with you & seeing them
_e reality. I've loved
_g so many firsts with
_om renovating our
_ to getting evacuated
_ & sharing our first
_ief marathon together
_ough you cheated &

Composition with Reserved Space

INSPIRATION #10

—

When you sit down to write, it's easy to feel daunted by a blank piece of paper. We are conditioned to want to fill the whole page with writing. Try to stop for a minute before you put pen to paper and consider what you are writing and how you can create something with visual impact like Lauren Hung has created here.

The combination of free-flowing calligraphy and the straight edges of Hung's composition is very satisfying to look at. This tight-lettered calligraphy has an original, almost brush-lettered look, but it was created with a nib and ink. Hung says that this composition 'draws your attention equally to the clean space as the written text'. This unique layout is particularly impactful when used for framed pieces of artwork such as lyrics or quotes, and would look fantastic hanging on a wall.

When laying out your lettering, think about its positioning on the page. Consider using clean lines, and think about the blank space around your art as well as the lettering itself.

OPPOSITE:
Our 15th Anniversary

Festive Projects

APPLICATION #6

—

The festive period can be a great time to hone your calligraphy skills. Nikki Reif of Lamplight Lettering combined the use of digital calligraphy and photographic imagery to create the seasonal message seen here. Reif says, 'I chose the natural, unassuming character of chalkboard lettering but was able to create it digitally on the iPad. Even though it's digital, I still wanted it to look handmade.'

Allow plenty of time for research and experimentation to plan your style and source your photography. Take your time to find the perfect wording and then write something that will look delightful combined with photography in your final festive piece.

RIGHT:
Christmas Chalk Greeting

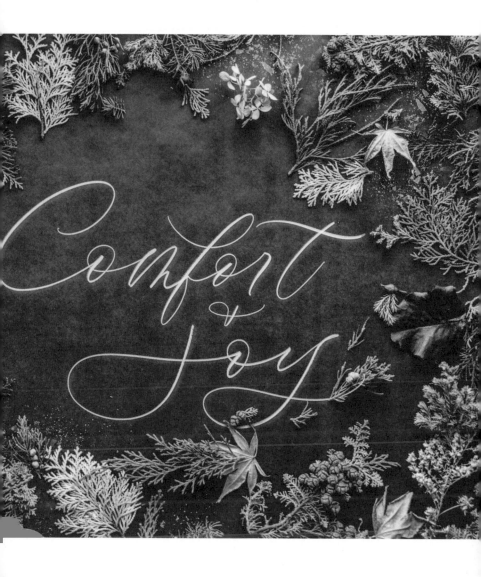

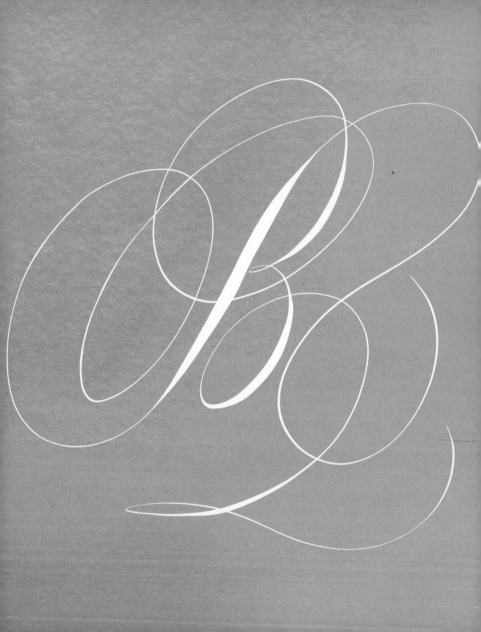

Elaborate Flourishing

INSPIRATION #11

—

Once you have become confident in your lettering style, it's natural to turn your attention to improving your letter flourishing. Not an easy task to begin with; it can be rather like learning calligraphy all over again, with its intricate fluid lines, strict oval rules and precise entrance and exit strokes.

Marisa Jackson's work is inspiring, not only for its delicate intricacy but also for how she has developed it using a multitude of techniques, including Spencerian and Copperplate. The modern bright gradient colours she's added to the examples on the right are a great final touch.

Start by working in pencil and consider some of the basic rules of flourishing such as not crossing two thick lines and keeping the flourish an oval shape. Create a library of favourite entrance and exit flourishes that you could use on certain letters such as a 'Y' or the descender of an 'M'. Once you have gained confidence with your skills, move onto more elaborate and difficult techniques.

OPPOSITE:
MarisaMade B

ABOVE:
MarisaMade E

Hot Foiling

TECHNIQUE #4

—

Just as letterpress goes well with calligraphy, so does the luxurious effect of hot foil. With the beautiful array of possible colours and the satisfying effect of debossing, there is much to admire about hot foiling.

Hot foiling is created in a similar way to letterpress, but instead of using a polymer-based plate, a metal plate is used. The process is very popular in luxury wedding circles, demonstrated here by Zoe Lacey of The Golden Letter. Each of her invitations are hand-pressed, and the plates used are magnesium or copper. Lacey says, 'I like to use slightly unconventional processes such as transparent foils that are resistant to ink and dye – once you understand a material, you can push its limits.'

You can purchase a metal plate to foil your lettering at home, but it can be a time-consuming and sometimes costly process. The alternative is to find a local studio or printer to work with who can hot foil for you. Just send them a PDF or JPEG of your work and choose a foil colour.

OPPOSITE:
Monoline Calligraphy
hot foil printed

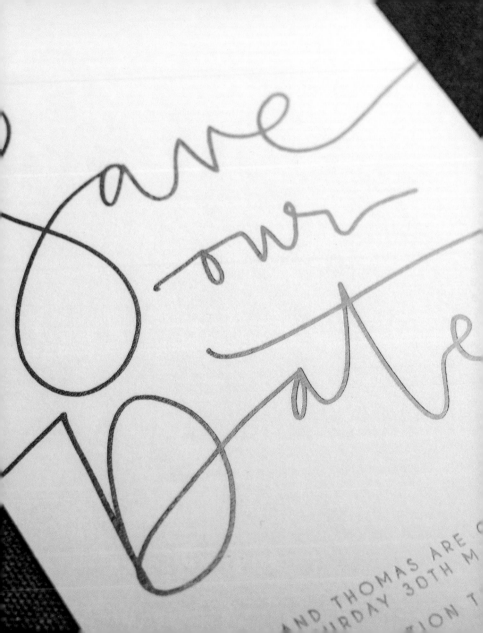

Save our Date

AND THOMAS ARE
URDAY 30TH M
TION

Gothic Fraktur

STYLE #5

—

Derived from Gothic-style calligraphy lettering, Fraktur is a very interesting, more legible form of blackletter that originated in the 16th century.

Yukimi Sasago Annand has created this modern piece of artwork with her take on quotes using Fraktur. She was inspired by her study of Johann Neudörffer's Fraktur. As with other calligraphy styles, if you want to try it, it's important to first research your topic, find calligraphers in that area and see how they work. See if they have written a book, posted online tutorials or even meet them for some mentorship.

You could create your own Fraktur work with a nib and ink, or if you want to start somewhere simple, I would recommend the inexpensive Pilot Parallel Calligraphy Pen.

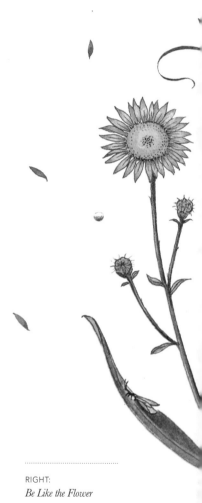

RIGHT:
Be Like the Flower

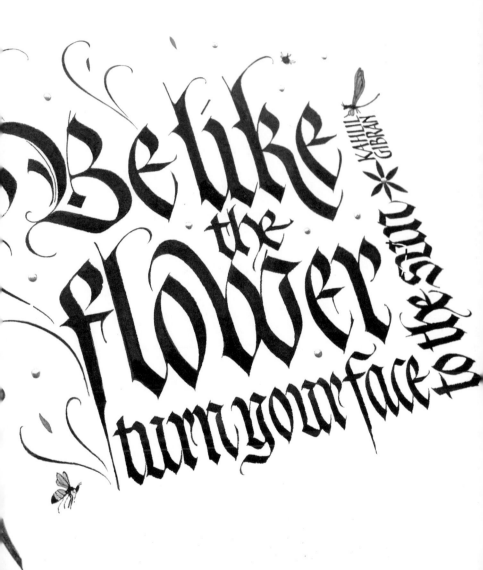

Be like the flower turn your face to the sun

KAHLIL GIBRAN

Let me not to the marriage of
true minds admit impediments.
Love is not love which alters
when it alteration finds
or bends with the remover
to remove: O no
it is an ever fixed mark,
that looks on tempests,
and is never shaken.

SHAKESPEARE · SONNET 116

Poetry

INSPIRATION #12
—

A poem written out in a calligraphy style can make a very touching and thoughtful gift. The lettering here is an excerpt from Sonnet 116 by Shakespeare, rendered by Rachel Icard of Cotton and Cursive. Her style perfectly compliments the flow of Shakespeare's work – the fluid flourishing combined with the iconic, beautiful words.

Shakespeare is a perfect start for any calligrapher, but why not try out some more modern or contemporary poems too? If you love the poem, then you will pour that love for it through your lettering onto the paper. You could even write your own poetry.

A nice smooth paper such as Bristol Board is perfect for this kind of work; the smooth surface of the paper allows the nib to glide through your lettering without catching on the paper – perfect for flourishing.

OPPOSITE:
Shakespeare excerpt from Sonnet 116

Monograms

TECHNIQUE #5

—

Although the focus is usually on the front of envelopes, you could enhance the design on the back with a customized monogram of your initials. Use handwritten calligraphy, letterpress or, as shown in the beautiful work here by Michaela McBride, you could even use a custom handheld monogram debossing stamp, applied to the reverse of the paper to create an embossed design.

First, plan your monogram structure. This can be more complicated than you might think since the connection of some letters does not naturally work well. If this is the case, you may need to alter your style of calligraphy slightly or incorporate flourishing to make the letters fit well together. Once composed, scan in your artwork and make any adjustments in your design program of choice. There are plenty of suppliers online who will turn your design into a stamp for a reasonable fee. Choose a good-quality paper stock for your envelopes to make the most of the beautiful embossed effect.

OPPOSITE:
*Custom Debossing
on envelope*

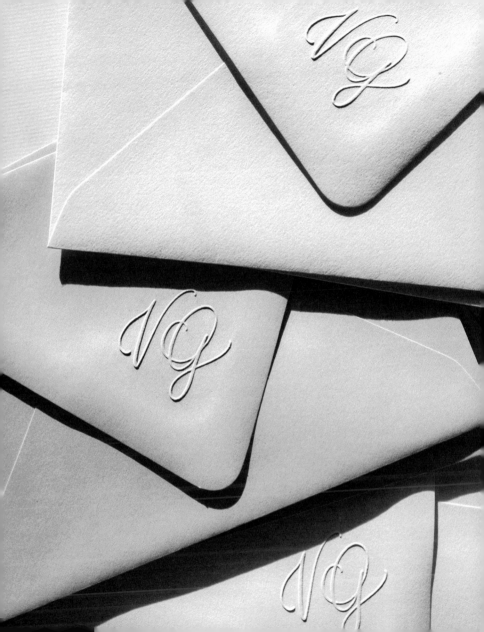

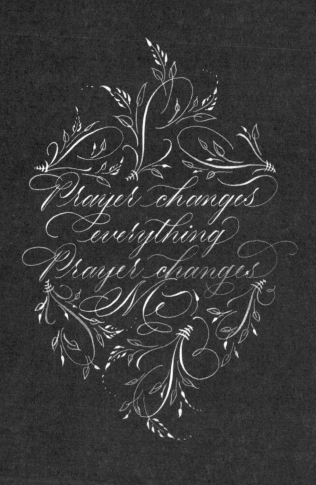

Prayer changes everything Prayer changes Me

Detailed Flourished Framing

INSPIRATION #13

—

Composing, lettering and framing your inspirational quotes is an enjoyable and fulfilling process that will encourage you to discover and develop your own style. Once you have mastered this, the next step could be to add flourishes to your artwork. This could be in the form of flourished lines or, in the case of Cherilon Stevens, a stunningly ornate flourished illustration.

Firstly, find out how to develop flourishes in your calligraphy style, making sure you practise those all-important elements (see pages 26, 53 and 71). Secondly, use an ink that will flow freely and not run out during your flourishing. Here, Stevens has used a Dr. Ph. Martin's Bleed Proof White combined with a Hunt 101 nib, using an oblique penholder.

Work on a few framing flourishes that you can reuse and keep in your repertoire – they could be a particular end-of-word flourish, a flourish for a particular letter or an illustrated flourish.

OPPOSITE:
Prayer 1

Felt Tip Pens

MEDIUM #7

—

Felt tips are not a classic medium that you might connect with calligraphy. They are, however, really versatile and you can create some beautiful pieces of work using them. Designed for use by children, they handle a lot of wear and tear, are brilliantly durable and there are several sizes available. These pens are ideal for Bounce lettering, and the fun nature of that style complements the pens very well. The look is similar to brush lettering, and the size of the nib will affect the weight of your strokes.

Belgian letterer Tom Bijnens has chosen a chunky size here to create his lettering. Think about layering your lettering with a gel pen as Bijnens has done to create a more elaborate effect; the gel pen works well because it sits nicely on top of the felt tip ink.

Be playful with this inexpensive medium, and experiment with different techniques: try blending them into each other to create a gradient effect, or dipping them into other inks so that the ink changes colour as you write.

ABOVE TOP:
Love Wreath Birthday

ABOVE BOTTOM:
Good Luck

OPPOSITE:
Happy Birthday

the world...

no idea of what is in...

wise and know the art of...

...cam of the unknown and accept whatever...

...nich the gods may offer it.

...this reason your customary thoughts all except the...

your friends, even most of your luggage — weighing...

in fact, which belongs to your everyday...

The Tourist travels in his own atmosph...

and stands, as it were, on his own...

at the continents of the...

But if you discard...

...rely and...

Define Your Own Style

INSPIRATION #14

—

The beauty of Modern Calligraphy is that you can pick and choose the elements of more established historical styles to create your own unique look.

Alice Gabb demonstrates this perfectly here with her Bounce calligraphy style that incorporates Copperplate flourishing. This unique calligraphy technique, with elongated and quirky lettering, is instantly recognizable as her personal style.

To start building up your own unique style, research modern and traditional calligraphy styles, find like-minded calligraphers and connect with them, and read books that contain source alphabets for you to work through. As you progress on your journey, you will soon see the influence of these sources in your work.

OPPOSITE:
Anniversary Poem

Place Cards

APPLICATION #7
—

Watching your guests' faces light up at a dinner party or wedding reception as they lay eyes on their names beautifully written in calligraphy is a fantastic experience. Rachel Icard of Cotton and Cursive has perfected writing name cards, managing to flourish her lettered names within the small space available.

Place cards are a great starting point for new calligraphers. You can begin making your own with handmade cotton paper or buy pre-cut tent-fold place cards online. Always make sure that the quality of the paper stock is matched by the ink to avoid any bleeding or smudging – remember that these are likely to become treasured keepsakes.

RIGHT:
Place cards

Margaret & ...

Emily Monroe

...llard

Nancy

Kathleen Watkins

Graham Chapman

Quotations

INSPIRATION #15

—

Calligraphy can create the most exquisite artwork
when showcasing quotes, lyrics and passages of text, as
demonstrated in these artworks by Martha Marie Wasser
of Amour & Ink Paper Company.

Wasser says, 'Whenever I am in need of inspiration, I'll search
"Quotes about Creativity" and then go to town creating small
pieces with different fonts, mediums and styles.' To create similar
artworks of your own, there are numerous templates available
for purchase or free online resources that will help guide you
on how to position your lettering. Consider all the options: Do
you want your lettering to fill the full page, or to form part of
a shape? Will your lines be precise or curvy? Do you want to
add any embellishments?

Use a light pencil to draw guidelines and lettering to begin
with, then take advantage of a thinner paper stock such as
a layout paper to help place the lettering where you want it
– the layout paper is excellent for tracing over and remedying
any mistakes on previous attempts.

OPPOSITE:
Untitled – quotes
on creativity
(numerous authors)

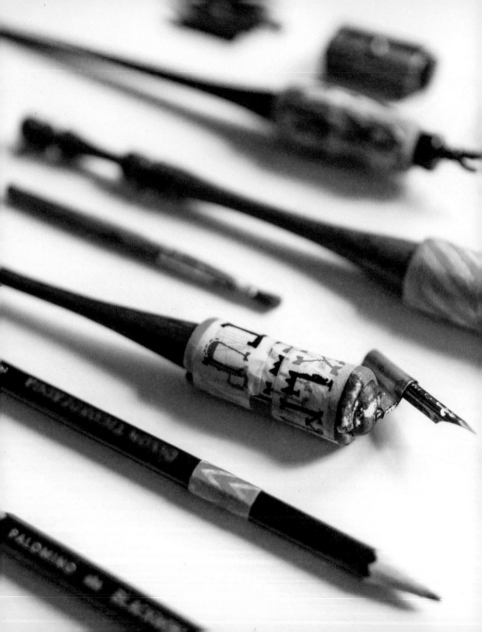

Make Your Tools Your Own

MEDIUM #8

—

Ask any calligrapher what their favourite tool is and they'd be hard-pressed to list just one item. For some, it's their penholders, for others it's the perfect nib or ink. You will also amass your own quirky collection of calligraphy tools as you continue.

Rachel Icard of Cotton and Cursive keeps a wide selection of favourite tools ranging from wooden oblique penholders to vintage nibs. Icard isn't afraid to customize her equipment – she says, 'I often do a lot of writing and, let's be real, sometimes it hurts your fingers. To remedy this, I cut up some of those foamy pencil grips to fit around the grip. They're washi-taped on.'

If your penholder is uncomfortable, instead of buying another one, look to see whether you can adapt the one you have.

LEFT:
Calligraphy tools

Uncial

STYLE #6

—

Uncial calligraphy is an interesting lettering style known for its recognizable rounded alphabet, curved strokes and the fact that it is written in majuscule (all in capital letters). Here, Keiko Shimoda has developed her own Uncial style by ignoring the capital-letter rule and using a William Mitchen Round hand No.5 nib on Zerkall hammered paper.

Shimoda's letterforms have a rich consistency in their shape and flourish; she has incorporated lighter strokes and flourishing on her ascenders and descenders, which almost give the effect of a secondary style throughout this work.

If this is a style you haven't tried out before, why not make mastering Uncial lettering your next calligraphy challenge?

OPPOSITE:
Flowing River

the flowing river never stops and yet the water never stays the same

foam floats upon the pools, scattering, re-forming, never lingering long

So it is with man and all his dwelling places here on earth

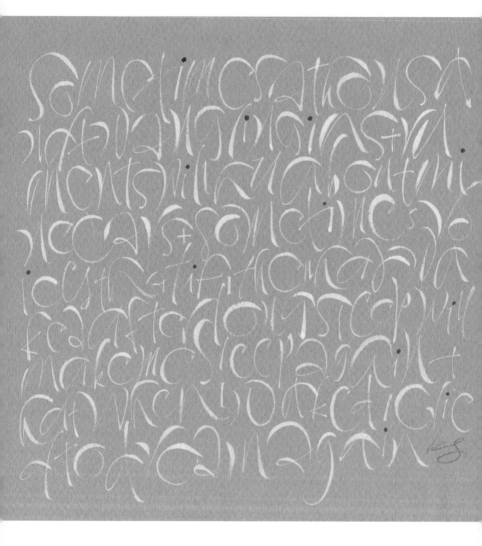

Brush Calligraphy

MEDIUM #9

—

One of the most interesting qualities of calligraphy is that you can make it your own by just changing one element. For instance, when trying a familiar style, you could replace your calligraphy nib with a brush pen or pointed paintbrush.

Keiko Shimoda experiments with various tools, and such created this elegant work with a brush. Shimoda says, 'This happened while I explored the alternative letter shapes which I can do with pointed brush, which is my nature from my Japanese Calligraphy experience.'

Experimenting with brush calligraphy can enrich your calligraphy skills and add another feather to your calligraphy cap. Not only that, it can open your mind to more varied styles and techniques when you return to using tools you may be more comfortable with such as nib and ink, as you will see the letterforms in a completely different light.

OPPOSITE:
Cried to Dream Again

there's no place like Home

Fabric Banners

INSPIRATION #16
—

Fabric banners have a great personalized and artisanal appeal and are very popular in the modern home and for weddings. Combined with some bespoke calligraphy, they make lovely keepsakes for friends and family members alike. Here, Joyce Lee of Artsynibs has created this banner by writing directly onto the fabric with a Posca brush marker.

You could design huge banners to make a fantastic backdrop for any event, or you could make small fabric banners as little favours for weddings. Think about whether you want to handwrite your lettering or have your calligraphy printed onto the fabric. To create a truly personal artwork, you could even embroider the lettering.

OPPOSITE:
Linen Banner for Home

Digital Calligraphy with Procreate

MEDIUM #10

—

One of the huge benefits of digital lettering on the iPad is the use of the Apple pencil alongside the Procreate app. Jillian Reece and Jordan Truster of Loveleigh Loops have perfected the art of digital lettering. They give the following tip: 'You can stabilize the strokes by adjusting the streamline. It can make your letters look smoother, and it follows your movement so the strokes appear to lock into place,' as seen above.

If you have access to an iPad, download Procreate and experiment with the streamline setting and stroke weight to create a bespoke brush that is unique to your style of lettering. There are so many different styles of brushes you can use from fine calligraphy to brush lettering. They all create a realistic calligraphy style that looks great both online and printed.

ABOVE:
Streamline 2

OPPOSITE:
Raspberry

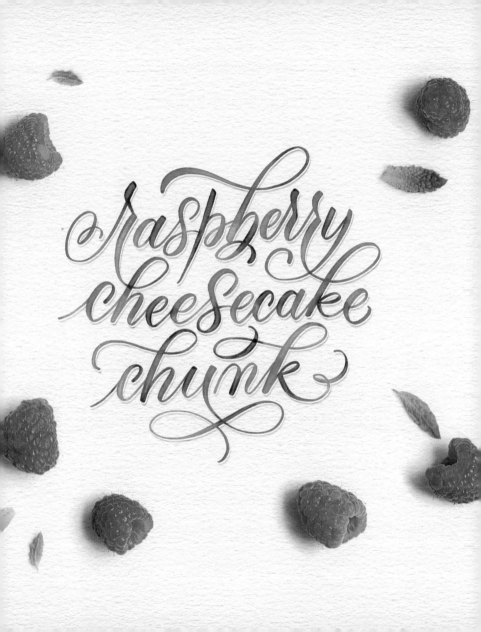

What if you're already your best self

Exaggerated Loops

INSPIRATION #17

—

Graceful loops are the perfect accompaniment to Modern Calligraphy, as shown in this work by Peggy Dean. Look at how her descender and ascender loops perfectly flow into the lettering in the lines above and below. Dean says, 'I love the delicate nature of airy letters that flow, almost as if they're gliding with a soft breeze. A steep angle accompanied with ornamental flourishes and exaggerated ascenders and descenders can give us a whimsical, romantic vibe.'

Experiment with loops, making them larger, finding new ways to flourish them and considering how thin your hairline strokes could go. Don't forget to consider the composition of your lettering as each line must still be legible.

OPPOSITE:
Best Self

Calligraphy with Paint

MEDIUM #11
—

Calligraphy with paint can be truly breathtaking. Thick, fluid letterforms can be used to create an utterly unique calligraphy style. Shadi Talaei produces her calligraphic artwork using Persian lettering in large formats to be hung on walls.

Talaei says, 'The use of calligraphy in the artwork does not symbolize Islamic religion or have any meaning in words *per se*, but it is particularly significant as a statement of Persian culture. I have used strong emphasis of different textures and depth of layers to bring about a sense of the many meanings of life brought about by the many emotions we feel throughout our experiences and encounters in our lives.'

Challenge yourself to recreate a favourite phrase or poem on a large scale with paint. Use a large paintbrush or palette knife applied to a canvas. Free up your writing and have fun exploring how you can letter at this scale and enjoy where this exercise takes you.

OPPOSITE:
Wings

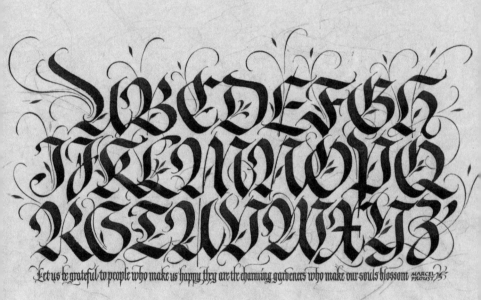

Let us be grateful to people who make us happy they are the charming gardeners who make our souls blossom MARCEL PROUST

Alphabet

INSPIRATION #18
—

A calligraphic alphabet listing all the letters from A to Z can be a wonderful work of art in itself. Here, Yukumi Sasago Annand has created a beautiful Fraktur-style flourished alphabet. Note how your eye is drawn to all the fine airlines, the broad edge of the strokes and the delicate flourishing – it is like a beautiful forest of letterforms, there to explore and enjoy at one's leisure.

Creating your own alphabet can be a useful way to see how all your letters relate to each other on the page. There are plenty of online and printed resources that will help you to understand the components of each character. Experiment with how you can interpret a style into your own format, elongating some edges and rounding off other strokes, while still keeping the essence of the style.

OPPOSITE:
Fraktur Capital Garden

When you rise in the morning, Give thanks
for the light,
for your life,
for your strength.

Give thanks for your food and
for the joy of living.

If you see no reason to give thanks,
the fault lies in yourself.

Digital Flourishing

TECHNIQUE #6

—

When it comes to experimenting with flourishing on paper, mistakes will inevitably be made and you'll cover a lot of paper. Instead of using pen and paper, you can practise and perfect your flourishing techniques on a computer, tablet or iPad.

Jordan Truster of Loveleigh Loops demonstrates this here. He says, 'Whenever I create a flourished layout, it takes many iterations to get it right. Even with lots of practise and experience, I work and rework the piece – it doesn't just spill out of the pen and look perfect right away.'

Using a layers tool, you can create many variations of your lettering, keeping what you are happy with and adjusting areas that still need to be worked on. When you are happy, you can blend all the layers together to create one final flat artwork.

OPPOSITE:
Flourish Draft

INSTRUCTIONS DE PL...
DU PROGRAMME
...ez-vous à naviguez entre estu...
feuille blanche est là pour vo...
vidéo : WWW.INSTAGRAM.COM/LORE...

25 . 08 . 2018
14:00 - WEDDING CEREMONY
ÉGLISE SAINT-CHRISTOLY,
SAINT-CHRISTOLY DE MÉDOC

18:00 - Garden cockt...
20:30 - Dinner and DAN...
PARTY at home
7 ROUTE DE SAINT-BONNET,
SAINT-CHRISTOLY DE MÉDOC
DRESS CODE - ...

1.

2.

3.

4.

5.

6.

7.

8.

9.

10.

12.

Origami

APPLICATION #8
—

The combination of origami and calligraphy are a creative designer's dream. Alice Gabb produced these unique create-your-own origami boats for use as a wedding invitation. How entertaining it must it be for the recipient to not only be informed of a loved one's nuptials but to then be able to hand fold each panel to reveal a paper boat!

To create your own origami/calligraphy masterpiece, first find a folding design that would work with your style of lettering. Don't forget to take into account the potential need to scale up the size of the artwork so it will fold down to a decent size when constructed. Either pre-fold your design to work out specific areas to letter, or fill the page before folding. You may wish to photocopy your lettering to experiment with the positions of the folds before settling on your design.

OPPOSITE:
Fold-up
wedding invitation

Gothic Flourishing

INSPIRATION #19

—

The flow and connectivity of Gothic flourishing can bring flat, linear work to life. The addition of flourishes to Gothic letterforms highlights the beauty of the style. In this artwork, Massimo Polello combines thick, broad-edged strokes in a black calligraphy ink with finer illustrative flourishes to create a beautiful piece of calligraphy.

Use a broad-edged nib and your ink of choice to create your lettering. Gothic, Uncial and Roman styles will work well to create this contrast. Be feather-light with your pen; you can use the edge of a broad-edged pen or nib to achieve this ethereal look. The addition of different coloured inks would further highlight the juxtaposition of the fine flourished strokes and the thick Gothic style.

OPPOSITE:
W
Elaboration capital
letter gothic W
pen and brush

Gaelic Script

STYLE #7

—

Gaelic script is the Celtic variation of Uncial calligraphy: you will often see it as part of designs that are inspired by Celtic tradition. Dilbag Singh's precise and spare lettering is a great example of this style.

When practising your own Gaelic lettering, you will need to start with a broad-edged nib and concentrate on moving down through the letter stroke, extending where necessary. Your pen should move in long, rounded, extended curves through letters such as 'T' and 'C', with a sharp pointed finish at the end of each letter, as demonstrated here in Singh's work. Experiment with where you need to position and twist your nib, and with whether you need to complete your lettering in one complete stroke.

ABOVE AND OPPOSITE:
Contemporary Recitation

Temperature

Illustrated Maps

INSPIRATION #20

—

Have you ever admired old maps and pondered the techniques taken to create them? As well as being highly practical, maps can represent so much: freedom, peace, ownership, independence and excitement.

Alice Gabb's illustrated map shown here is used to guide guests to the venues for a wedding. With sketches and hand lettering, it makes a wonderful keepsake, which could be framed and kept for generations to come.

Think of a location that fires up your imagination or somewhere in the world that you love. Map out its features with your calligraphy pen, adding illustrations of local attractions that make it special to you. Highlight some areas in a banner to add originality, and test your calligraphic skills by experimenting with different styles of lettering from Modern to Copperplate.

OPPOSITE:
Wedding map

Tredmore
House

CORFE
CASTLE

KINGSTON

It
Nicholas
Chur

MERIDGE

Square &
Compass P

WORTH MATRAVERS

ST ALDHELM'S HEAD

bir yükümlülük üst

fikri bile bir gün boyun

inmeme engel oluyor ve bazen

yükümlülüğü gerçekleştirmeden

bir gün önce endişelere kapılıyorum

ve iyi uyuyamıyorum, toplum için

ne girip yükümlülüğümü yerine ge

tireceğim gün geldiğinde ise kıma

men önemsiz ve hiçbir şeyi haklı

karmayan bir ilişki seçip de bulu

kendimi, yor ve ben b

ve öğrenme

Formal Italic Lettering

MEDIUM #12

—

The flourished and curved lettering of Modern, Copperplate or Spencerian may not be the styles for everyone: some find the more rigid, simplistic structure of Italic more inspiring. Originating in Italy, this clean Italic letterform is a familiar classic script.

Calligrapher Furkan SARAL's Italic style is inspired by Hermann Zapf (famous for his typefaces). Taking inspiration from this formal Italic lettering, SARAL has created a very elegant piece of work with his extended ascenders on the letter 'H' and the extended descender on the letter 'F'.

To practise your own formal Italic script, make sure you have guidelines in place and remember to keep your lettering at an angle and to curve the end of your stroke. Aim to achieve consistency of lettering shapes and spacing. It's also a great opportunity to hone your fountain-pen skills.

..

OPPOSITE:
French roundhand script
Aurora Black ink,
Osmiroid nib

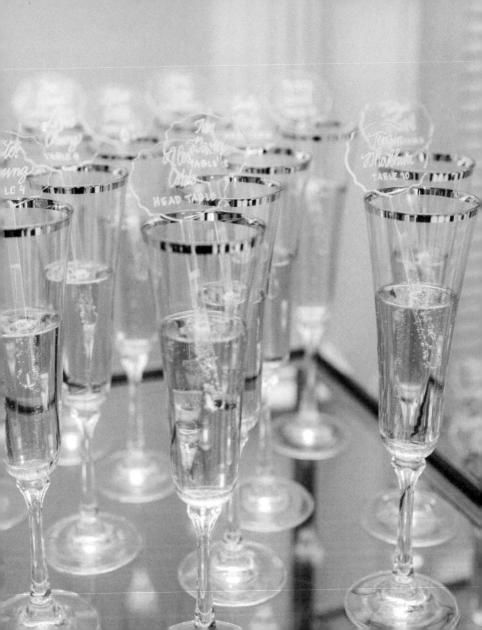

Acrylic

MATERIAL #3

—

A popular application for calligraphy is that of writing, printing or laser cutting directly onto acrylic. You can create effective place settings, table plans, menus, signs or, as demonstrated here by the work of Seattle-based calligrapher Camille Robinson, drink escort cards.

Robinson says, 'Acrylic is a fairly forgiving medium. If you mess up or want to change the lettering, simply using an alcohol-based solution will easily wipe off any paint or pen. This makes it easier for beginners, and it's a sustainable way to reuse materials!'

Acrylic is widely available online from various sources. Remember to consider the thickness: if it will be freestanding, it must be thick enough not to bend. Write directly onto the surface with your calligraphy pen using waterproof ink as Robinson has done here. To simplify the task of writing onto a clear acrylic, you can pre-print your design and trace over it.

OPPOSITE:
Escort 'Card' Display

Historical Penmanship

INSPIRATION #21

—

There is never only one way to write a certain script, and once you start delving into the history of each style, there are plenty of fascinating and inspiring stories to be found about historical calligraphers. Take Louis Madarasz, for example, one of the greatest ornamental penmen of the 19th century. His signature style, and the speed with which he composed his letterforms, earned him a great reputation in the USA, where he was renowned and revered.

IAMPETH holds an extensive collection of reference material on historical penmanship online, giving modern calligraphers the chance to step back in time and have the work of calligraphy masters at their fingertips. Use this archive to research historical calligraphers to inspire you, as Furkan SARAL has done here. He referred to work created by Madarasz to experiment with this iconic style.

OPPOSITE:
Copperplate script

*Yüreğin adamakıllı sar
ulabilmesi için ille de
kaderin güçlü tokadı ya da her
şeyi sertçe söküp atan bir güç
gerekmez her zaman, hatta gelişi
güzel nedense yıkımı yaratmak, ka
derin ele avuca sığmaz heykelti...
raş isteğini tahrik eder. Biz...
oğlu, kendi anlaşılmaz ... bahane
bu ilk hafif dokunu... ...zde
deriz ve onun o ... cücük cüssesine
rağmen çoğu zaman...)*

is a conta

quire an artistic

that can be taught consi

learned and possessed consi

Incidentally, not everyone u

to the rules. People point

following rules. He's doing

one before, something for whic

that the artist follows. The

making a painting or sculpt

paints and applying tr

sculptor must ha

tter how o

Attention to Detail

STYLE #8
—

It can be such a pleasing surprise to see line upon line of carefully executed words and to realize that these were all delicately created by hand.

Dao Huy Hoang has created this artwork in English Roundhand using a quotation from *How to Read A Book* by Mortimer J. Adler and Charles Van Doren. You can see guidelines for the tops and bottoms of his letters drawn out in pencil, which will be carefully removed later.

To create a similarly perfect spread of lines and lettering, you must first research what guidelines you need for your letterforms. Careful consideration of the placement of your nib and an awareness of the angles you need to achieve is also essential. Similarly, you must be aware of exactly where in each stroke you release the pressure – every tiny element will play a part in creating such a detailed work.

OPPOSITE:
From *How to Read a Book* by Mortimer J. Adler and Charles Van Doren

Clothing

MATERIAL #4

—

When we think of wedding calligraphy, initial thoughts go to inky hand lettering on fine paper place cards or wedding stationery. However, there are plenty of other ways in which calligraphy can be incorporated into a big celebration. This beautiful statement-piece jacket, created by Nikki Reif of Lamplight Lettering, was worn by a bride on her wedding day. Reif has hand painted the lettering in a modern, elegant style, which creates a brilliant contrast with the edgy leather jacket.

To create your own unique hand-painted piece of clothing, have fun searching for inexpensive items to use as the perfect canvas. You'll need to be aware of what sort of ink or paint is suitable for the different kinds of fabric, and choose your writing implement wisely. In this piece, Reif used a number 1 round brush with a leather acrylic paint.

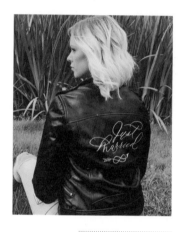

ABOVE AND OPPOSITE:
*Just Married
leather jacket*

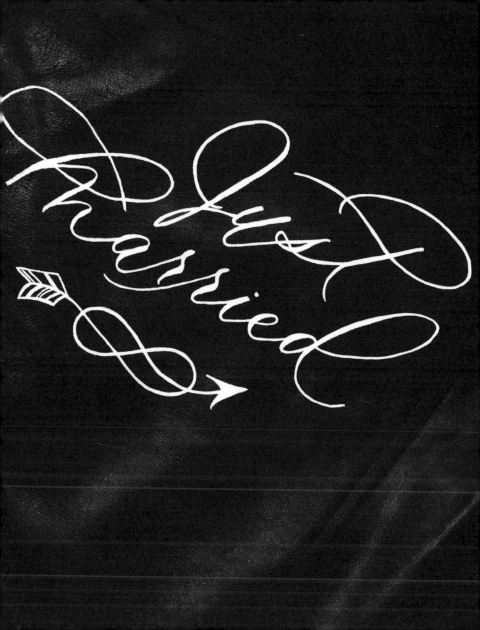

Oh soul,
You worry too much.
You have seen your own strength.
You have seen your own beauty.
You have seen your golden wings.
Of anything less,
why do you worry?
You are in truth.

Legibility

TECHNIQUE #7

—

Precise entrance and exit strokes, and consistency in the shape of the letterforms, all help to create a calligraphy style that is a pleasure to read. This piece of work by Soraya Veldhuizen of Sorro.nl Kalligrafie demonstrates this by combining classic Copperplate along with her own style to create a piece of harmonious artwork. Veldhuizen says, 'To me, consistency is important: for the eye but also for readability. I try to show that in all my work.'

To ensure your work is not only beautiful but looks consistent and is legible throughout, try using an oblique penholder, a lightbox and/or guidelines, as Veldhuizen has done here.

OPPOSITE:
Oh Soul

Figurative Art with Flourishes

INSPIRATION #22
—

Figurative art filled with flourishing can be created by taking inspiration from your surroundings, favourite pieces of artwork or shapes and patterns. As Amarjeet Sonkar of Being Uxer has proven here, intertwining calligraphy embellishments throughout a design makes it possible to produce a form that is instantly recognizable. The weight of the stroke through the flourishes helps to connect all the elements of line art together.

Create your own flourished art by first drawing the outline of your subject in pencil, making sure you choose something small and fairly simple if this is your first attempt. Use your imagination to plan your subject, then hone your flourishing techniques with your illustration and calligraphy skills. Using the nib and ink of your choice, fill the shape with a variety of your favourite flourishes. Once your ink is dry, rub out the pencil guidelines to leave only the flourished artwork.

OPPOSITE:
Abstract Flourishing

Baubles

MATERIAL #5

—

Everyone loves a personalized gift at Christmas. Baubles are great for this and can be enjoyed anew every year. Lauren Cooper of Oh Wonder Calligraphy makes unique baubles, lettering them all individually with names or initials and in a personalized colour palette. She even finishes some baubles off with a luxurious gold leaf.

Why not make some yourself, with different colours, patterns and, if you're feeling brave, illustrations! They can evoke a memory, an important date or the name of a loved one. Ceramic baubles are available in craft shops, though you may need to prepare the surface as they can be rough to write on, resulting in wobbly lettering. To give a smoother surface, paint the baubles with acrylic paint and seal with a clear varnish.

For the writing, you can use a nib and acrylic ink, which will dry and not be rubbed off. You could also use a pen such as a Sakura Pen Touch, which will leave a thicker stroke, giving the appearance of a Bounce lettering style, which you could go over with ink to create faux calligraphy.

OPPOSITE:
The Baubles

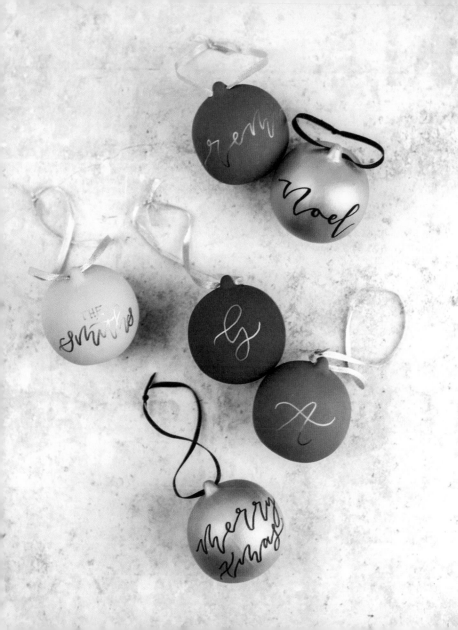

Cyrillic Letterforms

INSPIRATION #23
—

Most calligraphy styles can be applied to alphabets and scripts from around the globe. Here, Moscow-based calligrapher Valeriya Shiryaeva of Valerie Writes Calligraphy demonstrates the stunning combination of Cyrillic letterforms and Copperplate calligraphy. Shiryaeva has written out the poem 'Listen' by Vladimir Mayakovsky, adapting Copperplate into her own style of lettering and flourishing. Where the poem talks about stars in the sky, she has added these to her work in the form of star illustrations and has used dark paper to replicate the night sky.

If you are more used to the Latin alphabet, Cyrillic script may not be easy. If you are interested in lettering in Cyrillic, it's advisable to sketch everything out first to make sure you have the correct spelling and letter placement. You can then go back and add flourishes as you normally would.

OPPOSITE:
Excerpt from the poem 'Listen' by Vladimir Mayakovsky

Послушайте!

Ведь, если звёзды за[жигают] —

значит — это кому-[нибудь нужно?]

значит — кто-то хочет,

значит — кто-то...

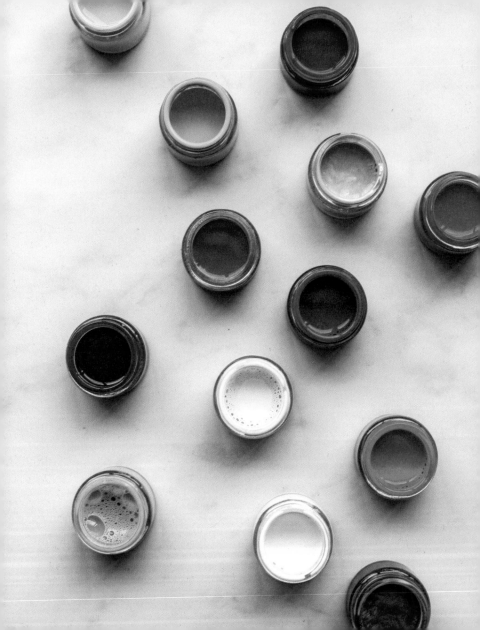

Homemade Ink

MEDIUM #13

—

From Ziller to Finetec, walnut to iron gall, the list of inks to experiment with and obsess over is vast. Different inks will work well for different projects: a thinner ink, for example, is great for flourishing as it won't run out as quickly.

Lauren Cooper of Oh Wonder Calligraphy makes and sells her own inks. She creates complementary palettes from pastels to bright summery colours and festive reds and greens.

While it can be tempting to snap up every shade and type of ink you see, there are inks that are relatively easy to create yourself at home. You can make an acrylic-based ink from good-quality acrylic paint mixed with distilled water. Similarly, you can make an ink from gouache paint mixed with gum arabic to bind the water and gouache together. For metallics, mix Pearl Ex powder, gum arabic and water in equal parts, and blend to make the consistency of your choice (adding more water for a thinner ink).

OPPOSITE:
Handmade inks

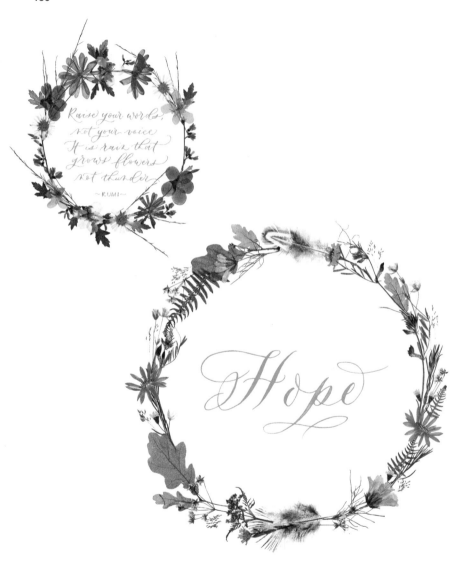

Raise your words,
not your voice.
It is rain that
grows flowers
not thunder.

~RUMI~

Hope

Floral Decoration

INSPIRATION #24

—

OPPOSITE TOP:
Raise Your Words

OPPOSITE BOTTOM:
Hope

Adding dried florals to create a three-dimensional organic composition to sit alongside your calligraphy can turn a calligraphic artwork into a framable piece of creative artistry. Gemma Milly says, 'I take inspiration from the natural world around me, and I work with fellow creative Wilder & Wren to create these floral prints. The flowers and petals are foraged locally and pressed by hand, before being photographed to enhance their transparency. My calligraphy is then handwritten in pen and ink using a Tom's Studio calligraphy pen and Nikko G nib, and the final artwork is put together in Photoshop.'

Why not use dried florals for your own composition? Either add them directly to a canvas or paper stock, or lay them out and photograph them to finish the project digitally.

Abstraction

TECHNIQUE #8

—

Abstraction may not be something you usually associate with calligraphy, but it is nonetheless an unusual technique you can employ in your work. Jake Rainis, a calligrapher based in Boston, USA, creates dynamic and unique artworks in a style known as 'calligraffiti'.

Rainis says, 'Start small by drawing a square box lightly with pencil and begin filling it with shapes. You can start in one corner and work your away across the whole box, or you can start randomly placing strokes and fill in the gaps as the box starts to fill up. Once you start laying shapes down, you'll quickly get a feel for how these compositions can work together.'

For composition inspiration, research 'calligraffiti' online and see what techniques have been employed by other lettering artists. Consider writing on a larger scale or in an irregular shape – this technique is all about exploration with different sizes, mediums, inks and tools.

OPPOSITE:
Exercise in Abstraction 2

ABOVE:
Exercise in Abstraction 3

Numbers

INSPIRATION #25

—

Numerals are often left at the bottom of the list when it comes to inspirational calligraphy – there is a tendency to study quotes and poems and not consider the merits of numeric calligraphy. As Julia Razzhigaeva's stunning example shows here, you can apply the same flourishing and composition techniques to numerals as you would to letters.

Razzhigaeva has connected the numbers using flourishes and intertwining fine lines between each number to bring them together in one whole composition. She used walnut ink, a Hunt 22b nib and an oblique penholder.

Why not practise writing the day's date every morning in a different style of calligraphy? Once you've had plenty of practice, take a meaningful date, for instance a wedding date, birthday or graduation day, and see if you can create an impressive artwork around it.

OPPOSITE:
DATE

Mural

APPLICATION #9

—

This large-scale wall mural painted by Angi Phillips of Angelique Ink demonstrates the versatility of the art of calligraphy. Developed as part of a local showcase, Phillips created a bespoke 'wavy, legible script as a nod to California's casual vibes and beach waves.' She began by writing out the lettering on paper first. This was then digitized and laid out with the rest of the design, including the plant border. The finalized design was then projected onto the wall and the traced outline was painted over with lettering enamel.

Look around your home to see if there is a wall or door that would suit this style of decoration. Be brave and think about the composition and lettering style that could work within your own environment. You could even consider creating a large-scale community project in your area.

OPPOSITE:
California Dreamin'

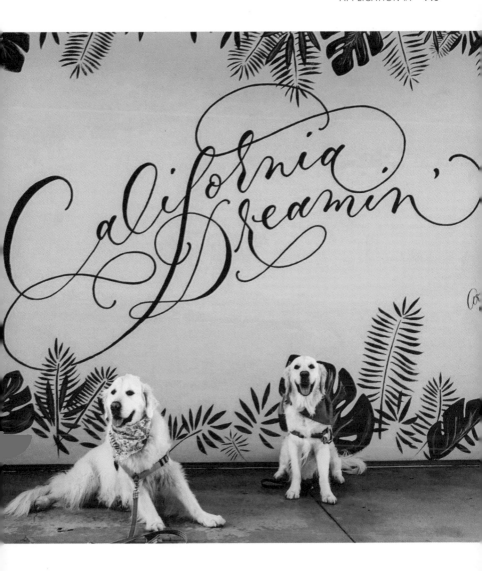

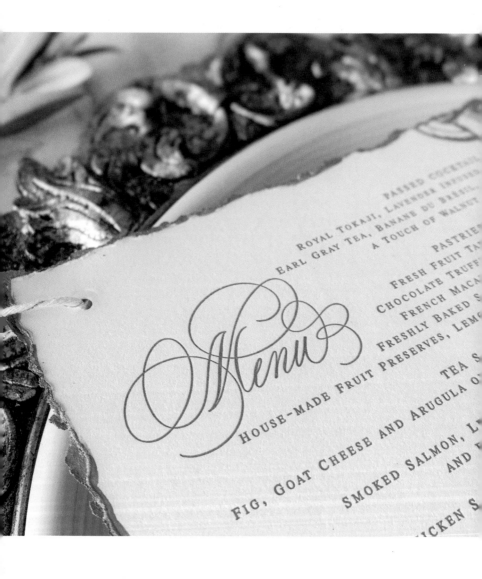

PASSED COCKTAIL
ROYAL TOKAJI, LAVENDER INFUSED
EARL GRAY TEA, BANANE DU BRESIL
A TOUCH OF WALNUT

PASTRIES
FRESH FRUIT TA
CHOCOLATE TRUFF
FRENCH MACA
FRESHLY BAKED S
PRESERVES, LEMO

Menu

HOUSE-MADE FRUIT PRESERVES

TEA S
FIG, GOAT CHEESE AND ARUGULA O
SMOKED SALMON, L
AND F

ICKEN S

Menu

STYLE #9
—

A beautiful piece of calligraphy can be worth keeping forever. A menu for a special event or location – such as this one created by Kestrel Montes of Inkmethis Calligraphy & Engraving – can be saved and the dishes savoured all over again through memory. Montes has used elaborately flourished calligraphy to highlight the main aspects of this example. While Montes has used flourishing in great detail, she has balanced it beautifully by keeping it to only the first and last characters of each word.

Why not create your own menu to mark a special event? Try different sizes and formats such as a large square or a folded leaflet, and consider decorating the edges first. You could hand deckle the edging and apply gold leaf, or even run a flame around the edges to give it a vintage feel. Make sure to do this before you create your beautiful lettering in case of mishaps!

OPPOSITE:
Waldorf Astoria Chicago
Tea Party Menu

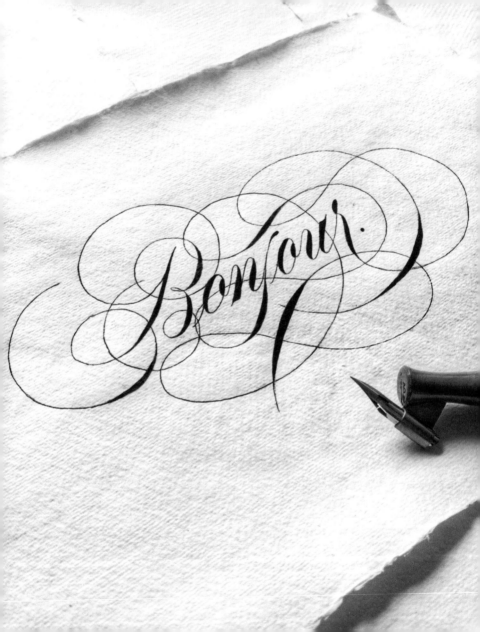

Doodling

TECHNIQUE #9
—

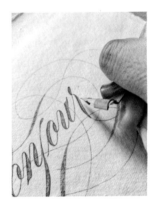

OPPOSITE:
Bonjour

ABOVE:
Bonjour (in-progress
close-up)

Plenty of calligraphy artists start new pieces by sketching their designs with a pencil. But doodling with a pencil in a less formal, more creative way can spark the imagination at the start of a project. Experiment with a favourite word or produce elaborate new flourishing styles, as Jeremy Tow has done in his artwork featured here. Tow says, 'I came up with this artwork doodling with my pencil, I didn't have a specific idea.'

Pick up a pencil and see where just doodling takes you. Let your lettering be free and fluid one minute and structured and formal the next. Once you are completely satisfied with your design, you can start to apply nib and ink to paper.

Wrapping Paper

APPLICATION #10

—

Modern Calligraphy is an extremely versatile style that can be used in a variety of projects. Take this Christmas wrapping paper created by Judy Broad Calligraphy, for example. Broad has used rolls of brown and white kraft paper and a Tombow brush pen to create a unique repeating calligraphy pattern of festive words finished off with some lovely Christmas ribbon.

Broad says, 'This is a super easy, economical and fun project. Don't spend money on fancy wrapping paper!'

Why not create your own personalized wrapping paper? You could feature your recipient's favourite quote, part of a poem that they like or their favourite song lyrics.

OPPOSITE:
Christmas
wrapping paper

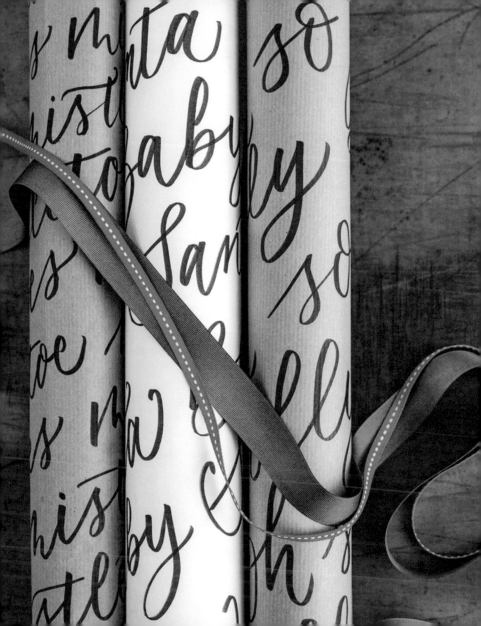

Engraving

TECHNIQUE #10

—

Singapore-based calligraphy artist Joyce Lee of Artsynibs doesn't like to confine her calligraphy to paper. She says, 'Perhaps the rebel in me wants to constantly push the boundaries on what we can leave a very human mark on, something handwritten in this case.' Opposite, she has engraved a message onto a glass candle and detailed it with gold gilding wax, creating what could be a beautiful gift or an attractive personalized item to sell.

To create engraved projects, you will need an engraver's pen. Such pens are widely available online; make sure the one you choose has a variety of attachments so you can try different techniques. Lee uses a Dremel 3000 for her work.

Experiment with engraving song lyrics on mirrors, or messages on bottles of champagne for thank-you gifts – if you can engrave on it, then you can calligraph onto it, too.

ABOVE:
Make Up
Brush Engraving

OPPOSITE:
Candle Jar Engraving

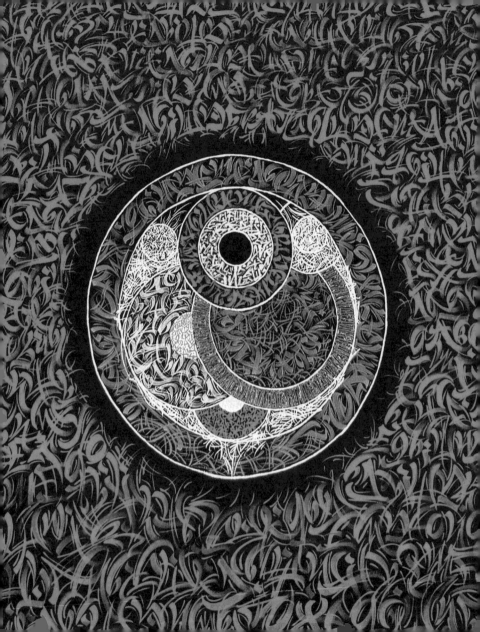

Make Your Own Tools

MEDIUM #14

—

Combining your own tools to produce a unique calligraphy style, as Anton Khaustov has done here, takes a level of bravery and confidence, but if you want to push your practice to the limit, you too could create some truly individual and aesthetically mind-blowing artworks. Here, Khaustov has combined tools such as a folded pen with calligraphy to create a piece that looks almost Arabic in style.

It can be surprisingly easy to obtain the necessary materials and expertise to create your own calligraphy tools from scratch. Peruse the many templates for various tools online. For instance, to create your own ruling pen, you need only to cut the metal of an empty drinks can and, following a template, fold it down around the end of a pencil into the recognizable ruling-pen shape.

OPPOSITE:
Are You Still Breathing?
I am Still Breathe

Celtic Versals

INSPIRATION #26

—

Versals are a type of Celtic illuminated lettering. Oriol Miró Genovart has constructed this amazing artwork (made up of a quote from a cookery book by Catalan author Josep Pla) by expertly combining some tricky elements into a stunning unity of letterforms. The unique interaction between Celtic versals and Uncials written in Catalan draws the reader's eye along the spiral.

If you are interested in Celtic lettering, then let this piece of calligraphy artwork inspire you and make you push your creative boundaries. Why not explore illuminating your own lettering – starting small at first, and then leading up to more elaborate designs? You could also use historical documents and manuscripts to inspire and inform your work, as Miró Genovart has done here.

OPPOSITE:
Celtic Spiral

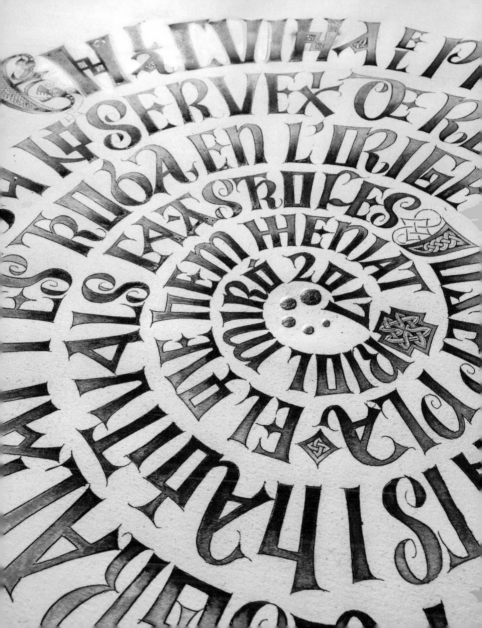

Wood Burning

TECHNIQUE #11

—

Wood burning is an alternative to engraving that involves searing your lettering into a piece of wood with a pyrography tool to make items such as table place names, a newborn name souvenir, or a sign for the front door. The possibilities are vast with this technique: you could use new or reclaimed wood, vintage furniture, found scrap wood or driftwood.

Mallow Romportl of My Art of Gold has created this beautiful calligraphic piece on a natural wood slice for a rustic feel. Before embarking on a project, think about the kind of wood burner and burner tips that you might need for your design. Romportl says, 'My two personal favourites are the ballpoint tip used specifically for calligraphy and the universal shading tip, which I use for those extra fine details.'

You also need to decide whether you would like to write freehand or mock up your design and transfer it using graphic paper, as Romportl does for particular pieces of illustrated work.

OPPOSITE:
Adventure

Business Cursive

STYLE #10
—

Taught in the 19th century at business schools, Business Cursive is a very distinctive style, not least because it doesn't use any shading on the down strokes, making it very monoline in style.

The lettering shown here, created by Furkan SARAL, has a lovely flowing style with the long connection strokes joining each letterform together and a distinctive entrance and exit stroke. SARAL has used a Montblanc 252 F fountain pen for his work in Iroshizuku Asa-Gao ink, written on a smooth Rhodia paper.

The most difficult aspect of this style for calligraphers will be to avoid applying any pressure on a down stroke. After years of training, this might be quite a challenge. Using a good-quality fountain pen or glass pen, as SARAL did in these examples, could help you in reproducing this style. *The Art of Cursive Penmanship* by Michael Sull is also a great resource for this style.

OPPOSITE TOP LEFT:
Business Cursive Script
Montblanc Irish
Green ink,
Montblanc 644 pen

OPPOSITE TOP RIGHT:
Business Cursive
Iroshizuku Asa-gao
ink, Montblanc
252 pen

OPPOSITE BOTTOM LEFT:
Business Cursive
Iroshizuku
Ku-jaku ink

OPPOSITE BOTTOM RIGHT:
Business Cursive
Glass pen

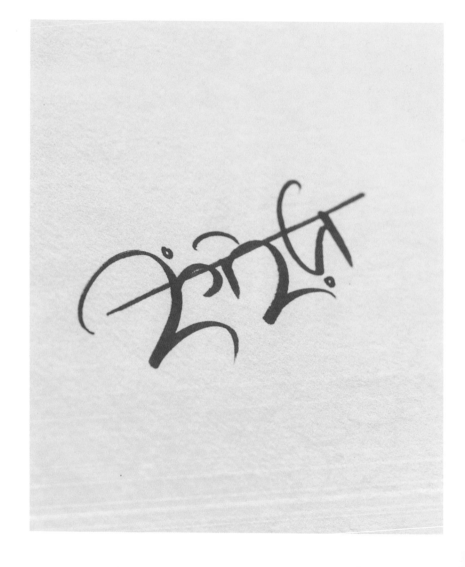

Devanagari Script

TECHNIQUE #12

—

Devanagari is a script originating in India from around the 2nd century, and is still in use for many languages across South Asia. Contemporary Indian calligrapher Dilbag Singh has used his own modern-lettering penmanship to produce a modern take on this ancient style of lettering. Singh uses a Copperplate manuscript EF Principal nib to create this lettering. By using such a flexible nib, Singh has been able to create large, elongated curves and fine hairline strokes.

If you are interested in exploring Devanagari, then studying the work of a modern penman such as Singh is a great place to start. Tutorial videos can be an excellent resource when it comes to understanding the placement of the pen and positioning of the nib. Explore how you can bring your own style to a more traditional script by working out the key recognizable features of both styles, and how they might be brought together.

OPPOSITE:
Varnakshar (Alphabet)

Wax Seals

MATERIAL #6

—

We can't discuss calligraphic inspiration without including monogram wax seals. Most popularly used nowadays in wedding stationery, wax seals are a great project for beginners learning Modern Calligraphy. You can have a lot of fun exploring different ways to letter initials and incorporate illustrations into a small stamp size, as Laura Elizabeth Patrick has done here. Wax seal stamps can come in a various sizes and shapes; a larger seal is generally more effective in keeping together elements of stationery such as a belly band, twine or a little sprig of foliage.

A great method for melting wax at home is to use glue gun wax; you can purchase it online in an array of colours from pearlescent to matt pastels, and the glue gun allows the user to create wax seals at a quicker rate than melting by hand. You can press gold leaf or small flowers into the wax before pressing with your cooled seal.

OPPOSITE:
Seal Close

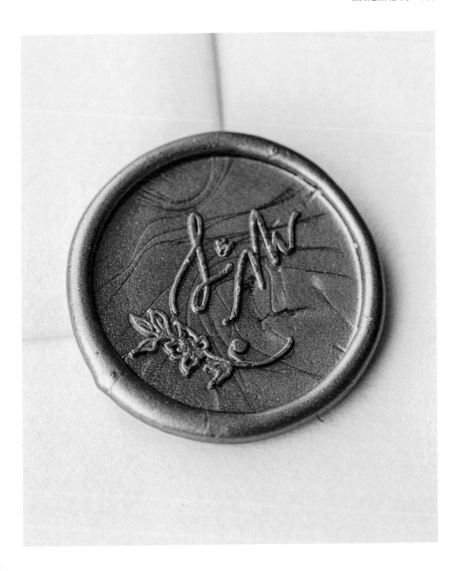

Signage

APPLICATION #11

—

Large-scale signage can seem daunting, particularly if you are not keen to negotiate with a printer. Here, Lisa Phung demonstrates how to create large signage yourself at home, transforming a large sheet of clear acrylic with a pastel paint and paint markers into a beautiful quote that can be used for events or hung in the home, office or shop.

Phung says, 'For these pieces, I always start with pen and paper, to either draw guidelines or prepare drafts.' This is great if you are worried about possible mistakes; you can trace the details, letter onto the acrylic and then add the background paint after. Phung adds, 'The advantage of using clear acrylic is that I can prepare a to-scale draft for the large pieces and place this underneath to "trace" the final. I work quickly with the acrylic paint markers to give a solid, opaque finish.'

To create your own signage, order large sheets such as this from any DIY store or online, apply acrylic or enamel paint onto the back of the sheet and letter directly onto the front.

OPPOSITE:
Welcome sign with acrylic paint on clear acrylic

Ombré Effect with a Parallel Pen

MEDIUM #15

—

Parallel pens can be great tools for beginners who want to master Fraktur lettering, as they glide smoothly on the page without having to re-ink. Stephanie Crisostomo of Stfnie.Ink created this ombré artwork using a Pilot 3.8mm Parallel Pen with a blue ink cartridge instead of the standard broad-edged calligraphy nib and penholder. Crisostomo says, 'I love using a parallel pen for Fraktur because it's easier to use. A fun way to write with it is by dipping the pen into a different coloured ink to achieve a kind of an ombré effect.' She used Lamy Vibrant Pink ink and Strathmore Watercolor Paper.

Why not try a parallel pen and experiment with watercolour ink and the different ombré effects that can be achieved for yourself?

RIGHT:
The World is a Book

Le monde est un livre chaque pas nous ouvre une page.

Alphonse De Lamartine

TOM BIJNENS, THUMP
P82–83
www.thump.be

JUDY BROAD CALLIGRAPHY
P148–149
www.judybroadcalligraphy.co.uk

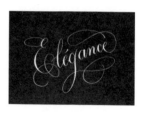

ZOÉ BROCHARD
P8–9
www.zoezephyyr.com

LINDSEY BUGBEE
P34-35
www.thepostmansknock.com

CALLYANE
P12–13
www.callyane.fr

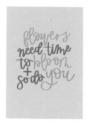

RUTHIE CAWLEY
P54–55
www.cawligraphy.com

HICHAM CHAJAI
P28–29
www.thearabiccalligraphy.com

LAUREN COOPER,
OH WONDER CALLIGRAPHY
P22–23, 130–131, 134–135
www.ohwondercalligraphy.com

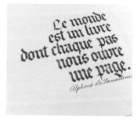

STEPHANIE CRISOSTOMO
P166-167
www.instagram.com/stfnie.ink

ANIKA DE SOUZA
P36–37
www.anikadesouza.com

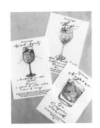

HARRIET DE WINTON
P64–65
www.dewintonpaperco.com

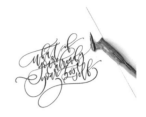

PEGGY DEAN
P100–101
www.thepigeonletters.com

ALICE GABB
P84–85, 108–109, 114–115
www.alicegabb.com

CLAIRE GOULD,
BY MOON & TIDE CALLIGRAPHY
P14–15
www.bymoonandtide.com

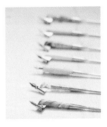

TOM GYR,
FOUNDER OF TOM'S STUDIO
P38–39
www.tomsstudio.co.uk

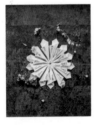

VERONICA HALIM CALLIGRAPH
P32–33
www.veronicahalim.com

DAO HUY HOANG
P122–123
www.huyhoangdao.com

LAUREN HUNG,
THE BLACKLINE BOTTEGA
P66–67
www.theblacklinebylauren.com

JOI HUNT
P10–11
www.bienfaitcalligraphy.com

RACHEL ICARD,
COTTON AND CURSIVE
P76–77, 86–87, 90–91
www.cottonandcursive.com

JANE IZUMI MATSUMOTO
P48–49
www.instagram.com/ginkgoarts

MARISA JACKSON,
ARTIST/CEO MARISAMADE LLC
P70–71
www.marisamade.com

RACHEL JACOBSON
P62–63
www.rachel-jacobson.com

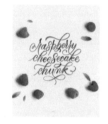

JILLIAN & JORDAN,
LOVELEIGH LOOPS
P98–99, 106–107
www.loveleighloops.com

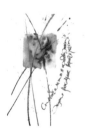

BAKHYT KADYROVA
P30–31, 42–43
www.instagram.com/aster.calligraphy

ANTON KHAUSTOV
P152–153
www.instagram.com/antoshause

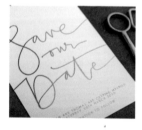

ZOE LACEY,
THE GOLDEN LETTER
P72–73
www.thegoldenletter.co.uk

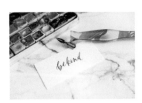

MAI LAGDAMEO
P58–59
www.instagram.com/mai.notebook

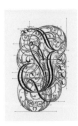

CHAE HO LEE
P16–17
www.instagram.com/heypenman

JOYCE LEE, ARTSYNIBS
P96–97, 150–151
www.artsynibs.com

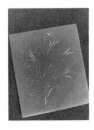

JESSY LIM
P52–53
www.jessycreates.com

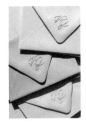

MICHAELA MCBRIDE
P60–61, 78–79
www.michaelamcbridecalligraphy.com

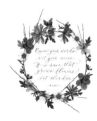

GEMMA MILLY
P136–137
www.gemmamilly.com

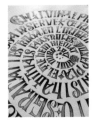

ORIOL MIRÓ GENOVART
P154–155
www.urimiro.com

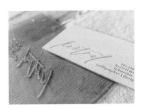

KESTREL MONTES, INKMETHIS
CALLIGRAPHY & ENGRAVING
P50–51, 144–145
www.inkmethis.com

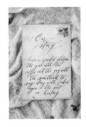

LAURA ELIZABETH PATRICK
P26–27, 162–163
www.lauraelizabethpatrick.com

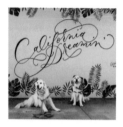

ANGI PHILLIPS, ANGELIQUE, INK
P142–143
www.angeliqueink.com

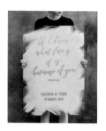

LISA PHUNG,
FOX AND HART
P164–165
www.foxandhart.com.au

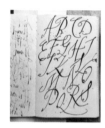

SABINE PICK
P24–25
www.sabinepick.com

MASSIMO POLELLO
P110–111
www.lacalligrafia.com

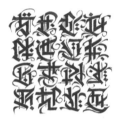

JAKE RAINIS
P138–139
www.jakerainis.com

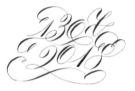

JULIA RAZZHIGAEVA
P140–141
www.instagram.com/juliarazz_c

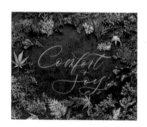

NIKKI REIF
P68–69, 124–125
www.lamplightlettering.com

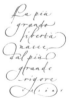

CHIARA RIVA
P46–47
www.instagram.com/chiar.riva

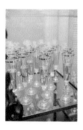

CAMILLE ROBINSON
P118–119
www.robinsoncreativehouse.com

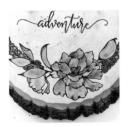

MALLORY ROMPORTL
P156–157
www.instagram.com/myartofgold

FURKAN SARAL
P116–117, 120–121, 158–159
www.instagram.com/furkan_saral_

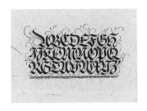

YUKIMI SASAGO ANNAND
P74–75, P104–105
www.yukimiannand.com

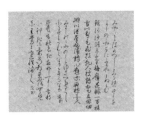

KEIKO SHIMODA
P56–57, 92–93
www.kcalligraphy.com

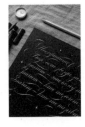

VALERIYA SHIRYAEVA,
VALERIE WRITES CALLIGRAPHY
P132–133
www.instagram.com/valerie_writes

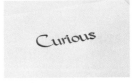

DILBAG SINGH
P112–113, 160–161
www.instagram.com/dilbag.insta

LAUREN SMITH,
LAURENINK
P18–19
www.laurenink.co.uk

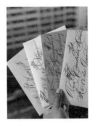

AMARJEET SONKAR
P44–45, 128–129
www.instagram.com/beinguxer

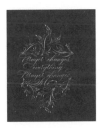

CHERILON STEVENS
P80–81
www.instagram.com/
lagniappecalligraphy

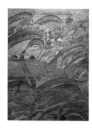

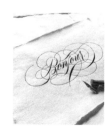

SHADI TALAEI
P102–103
www.instagram.com/shadi.talaeii

JEREMY TOW ETH
P146–147
www.jeremytow.com

MARIE TSUNEISHI, AINAMY TOKYO
P40–41
www.ainamytokyo.com

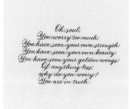

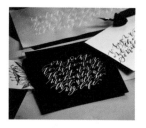

SORAYA VELDHUIZEN
P126–127
www.sorro.nl

MARTHA MARIE WASSER,
AMOUR & INK PAPER COMPANY
P88–89
www.amourinkpaperco.com

MICHELLE WONG, NOVEMBER
LETTERS
P20–21
www.november-letters.com

Lyndsey Gribble is a professional calligraphy teacher who runs regular courses for all levels at Plymouth College of Art. Based in Devon, England, she also organizes bespoke classes and workshops for schools and businesses. Lyndsey believes in the meditative, therapeutic and creatively stimulating nature of calligraphy. For more on the author, see @wildseacalligraphy.

ACKNOWLEDGEMENTS

I would like to thank all the calligraphers in this book for letting me feature and comment on their work. I have absolutely loved speaking to you all and am in awe of your talent and kindness. I'm certain the readers of this book will find your work hugely inspirational – it has certainly inspired me.

A thank you, too, for Zena Alkayat, who commissioned this project, and to my editor, Ellie Corbett, for your assistance in producing this book and for your consistent support, ideas and encouragement.

Finally, a big thank you to my lovely little family – Steve, Hope, Archer and Happy (the dog). You guys are the reason behind my motivation.

PICTURE CREDITS

7 Lyndsey Gribble; 9 Zoé Brochard, @zoezephyyr; 10 Bien Fait Calligraphy – Joi Hunt; 12 Callyane Calligraphy and Design by Callyane; 14 Claire Gould at Moon & Tide Calligraphy, photography by Vickerstaff Photography; 17 Chae Ho Lee; 18 Lauren Smith of Laurenink; 20 Michelle Wong, November Letters; 22, 131, 134 Lauren Cooper, Oh Wonder Calligraphy, photography by Holly Booth Photography; 24 Sabine Pick; 26, 163 Laura Elizabeth Patrick, @lauraelizabethpatrick; 28 Hicham Chajai, The Arabic Calligraphy; 31,42 Bakhyt Kadyrova; 32 Veronica Halim Calligraphy; 35 Lindsey Bugbee; 36 Anika De Souza; 38 Tom Gyr, Founder of Tom's Studio; 41 Marie Tsunishi, © 2019 AINAMY TOKYO; 44, 129 Amarjeet Sonkar, @beinguxer; 46 Chiara Riva; 48 Jane Izumi Matsumoto; 51, 144 Kestrel Montes, inkmethis Calligraphy & Engraving; 52 Jessy Lim, @jescreates; 55 Ruthie Cawley; 56, 93, 94 Keiko Shimoda; 58 Mai Lagdameo, @mai.notebook; 61, 79 Michaela McBride, photography by We are Origami Photo; 62 Rachel Jacobson; 63 Harriet de Winton; 66 The Blackline Bottega, Lauren Hung; 68, 124 Nikki Reif of Lamplight Lettering, @lamplight_lettering; 70 Marisa Jackson Artist/CEO MarisaMade LLC; 73 Zoe Lacey The Golden Letter, photograph by Diana Oliveira; 74, 104 Yukimi Sasago Annand; 76, 86, 90 Rachel Icard, Cotton and Cursive; 80 Cherilon Stevens; 82 Tom Bijnens, Thump; 84, 108,115 Alice Gabb; 89 Martha Marie Wasser, Owner, Creative Director of Amour & Ink Paper Company; 96, 150 Artsynibs; 98, 106 Jillian & Jordan, Loveleigh Loops; 100 Peggy Dean; 103 Shadi Talaei; 111 Massimo Polello; 112, 160 Dilbag Singh, India; 116, 121, 159 Furkan SARAL, @furkan_saral_; 118 Camille Robinson, Robinson Creative House, photograph by Wiley Putnam; 122 Dao Huy Hoang 2018; 126 Soraya Veldhuizen, Sorro.nl Kalligrafie; 133 Valeriya Shiryaeva, Valerie Writes Calligraphy; 136 Gemma Milly (calligraphy), Wilder & Wren (florals); 138 Jake Rainis; 141 Julia Razzhigaeva, @juliarazz_c; 143 Angi Phillips, Angelique Ink; 146 Jeremy Tow ETH; 149 Judy Broad Calligraphy; 152 Antos Hause, @antoshause; 155 Oriol Miró Genovart; 156 Mallory Romportl, My Art of Gold; 164 Lisa Phung, Fox and Hart; 166 Stephanie Crisostomo.